# Around Whetstone and North Finchley

## IN OLD PHOTOGRAPHS

# Around Whetstone and North Finchley

## IN OLD PHOTOGRAPHS

Compiled by
JOHN HEATHFIELD
*Photographs from the*
PERCY REBOUL COLLECTION

Alan Sutton Publishing Limited
Phoenix Mill · Far Thrupp · Stroud
Gloucestershire

First Published 1994

British Library Cataloguing in Publication
Data

A catalogue record for this book is available
from the British Library.

ISBN 0-7509-0650-2

Typeset in 9/10 Sabon.
Typesetting and origination by
Alan Sutton Publishing Limited.
Printed in Great Britain by
Redwood Books, Trowbridge.

# Contents

# Acknowledgements

Most of the pictures in this book come from our own collection. We acknowledge with thanks Barnet Museum Archives (p. 104), E. Hudgell (p. 151), R. Newton (p. 151), K. Ruge (pp. 78 and 124), A. Till (p. 121) and the Secretaries and members of the South Herts and North Middlesex Golf Clubs, all of whom willingly gave us permission to use their photographs.

No local historian can manage without the *Victoria County History* with its copious footnotes. There is little other printed material, and this book has largely been researched using original sources in the Greater London Record Office, the Barnet Borough Archives (where C.O. Bank's material is a monument to his industry if not to his judgment) and Barnet Museum.

Our gratitude goes to Joanna Corden and Pamela Taylor for their constant interest and encouragement, and in particular to Bill Gelder for his never-failing advice.

# Introduction

Historically speaking there are two Whetstones, a manor and a parish. In an indenture dated 1650 we read of 'The Manor of Whetstone in the Parish of Friern Barnet'. An Order in Council of 29 June 1836 created the 'Parish of Whetstone' out of part of the parish of Finchley. This book covers the district within about 3 miles of the old Great North Road (today's High Road) between Whetstone and Finchley. At its heart lies Whetstone crossroads, the meeting-place of two roads which may well have been in existence a thousand years ago.

One road ran from London through Highgate and Muswell Hill to what is now Colney Hatch Lane and then up Friern Barnet Lane to Whetstone and on to Barnet. The other ran from Totteridge (that is 'Tatta's ridge', a Saxon name) to Edmonton ('Edmund's town', also Saxon). Colney Hatch Lane became so muddy at the crossing with Strawberry Vale (where Tesco now stands) that the route north from Highgate was altered about 1385 to run straight over what became Finchley Common to rejoin the old road at Whetstone.

In early times the whole district was heavily wooded. We are reminded of that by names like Hollickwood, Woodhouse and Woodside. As London grew, the demand for wood for fuel and for building led to the destruction of woodlands. The demand for hay and grass to feed horses meant that large areas of pasture replaced them.

By about 1200 there was a settlement near Friern Barnet parish church, served by the road from London. When the road was moved west, the settlement probably followed it to form a 'West Town'. Early forms of the name include 'le Weston' in 1398, 'Wheston' in 1417 and 'Whetstonestret' in 1439. There is no truth in the old legend that the name comes from the soldiers sharpening their weapons on the way to the Battle of Barnet in 1471, since the name was used nearly a hundred years previously.

The term 'Great North Road' is not found much before 1700. The route was originally called the King's (or Queen's) Highway. Settlement along the road was sparse. The inhabitants depended largely upon the travellers for their living. Thus there were inns, smiths, harness makers, ostlers and the like. The road also formed an approximate boundary between the parishes of Finchley and Friern Barnet.

'Finchley' probably means 'Finch's ley' – a ley is a grassy space in a wood. At first, settlement was mainly round the edge of Finchley Common at Church End, East End and North End, an early name for Whetstone. A hundred and fifty years ago, North Finchley was largely undeveloped.

At one time, what is now Friern Barnet was called 'Little Barnet', a clear indication of its small size. An early form of Friern Barnet is 'Frerenbarnet' (1274), a reference to the brothers or knights of St John of Jerusalem whose headquarters were in Clerkenwell and who farmed the land. John Bacon leased a large parcel of land near the church in 1783 and purchased it in 1800. In January 1816 he raised a mortgage on the property. He died on 26 February 1816 leaving a financial tangle which kept the lawyers happy for twenty years or more. The estate was eventually sold at auction. John Miles later owned one part, Mrs Bethune another and the

third part became Friary Park and its surroundings. Friern Barnet Lane was called Wolkstreet about 1518.

Colney Hatch was never of commercial importance and consisted of only a few houses until 1849. In that year it was decided to find a site for an asylum for the lunatic poor on well-drained land with plenty of fresh air. Colney Hatch fitted the bill and the Colney Hatch Asylum was built. It boasted the longest corridor in Europe, but more to the point developed systems of caring for those unable to help themselves. The hospital was also a major employer.

Colney Hatch had its own railway station, later called New Southgate, where a housing estate was soon developed.

About 1880 the Brunswick Park estate grew up on a site isolated by the railway and the cemetery. It has always had a strong and friendly village atmosphere.

Totteridge is a linear village and has always had a small population. Since the Middle Ages wealthy men from London have bought estates here to enjoy the wholesome atmosphere and pleasant views.

The drop in land values during the second half of the last century caused agricultural wages to fall and also created unemployment. The construction of the railway in the 1850s took traffic away from the Great North Road and consequently took customers from all the inns and tradespeople dependent upon the road. There was great poverty in many homes, and some people committed suicide. It was not until the economic upsurge caused by the First World War that jobs were created and poverty began to decrease.

It would be difficult to overestimate the importance of public transport to the character and prosperity of the district. The electric trams, for example, which came in 1905, largely replaced the horse buses. They offered a frequent and inexpensive service which enabled the working class to travel to jobs in other parts of London. Local work had always been in short supply and up to the First World War was largely agricultural. A major employer was Sweet's Nursery. It had been founded in 1862 by J. Sweet, 'the father of the hot house industry'. Grapes, tomatoes, flowers and pot plants were grown and sent to market all over the British Isles. At one time they had over 20 acres under glass and it is disappointing that few, if any, photographs have survived.

The developing local population threw strains on the natural resources of the area. Wells and cesspits were no longer enough. There were also calls for adequate street lighting and gas for domestic use. So it was that gas mains were installed down the Great North Road by 1862 and sewage farms were constructed in the 1880s.

Our photographs are a precious record of all these changes. They show the transition from a horse-based agricultural economy with small farms supplying dairy produce to the locality plus hay and grass for the London market, to a bustling prosperous suburb within easy reach of the City and West End. The village-like character has been supplanted by blocks of offices, many of them decorated with 'To let' signs. The wheel has turned full circle: people from the Home Counties now come into a district to work where not eighty years ago cows were led along the Great North Road to be milked.

Nostalgia is a deceptive emotion and few living today would actually enjoy the poverty and squalor apparent in the region in those bygone times. I hope, however, that people enjoy this book, which provides a record of that leisurely, if less prosperous, age.

# SECTION ONE

# Around Whetstone and the Great North Road

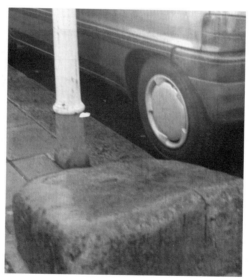

The old stone standing outside the Griffin Inn at Whetstone crossroads is made of quartz and sandstone, containing small grains of zircon, rutile and schorl. Such stone outcrops in the Yorkshire Dales and in south Wales and was laid down about 240 million years ago. How it got to its present position is a mystery. It may have been the base of a fair cross, and was certainly used as a horse mounting-block. There is, however, no truth in the old legend that Whetstone got its name from the soldiers whetting their swords on the stone before the Battle of Barnet in 1471.

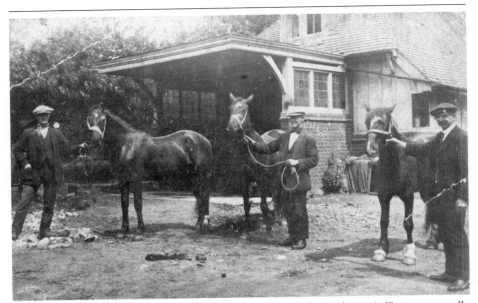

Two of the Appleby brothers (centre and left), who lived in Solomon's Terrace, proudly displaying the horses at Willenhall, *c.* 1930. Horses played as important a part in Victorian life as petrol engines do today. When horses were phased out, many jobs went with them.

Walfield was the house of the bailiff of the manor of Whetstone and Friern Barnet in 1485. It stood on the county boundary between Hertfordshire and Middlesex, and therefore between Barnet and Whetstone. The estate was bought by Henry Lauzan in 1796, and the house shown here was probably built by him. It was mortgaged about 1815 to provide money to help found the firm of Schweppes. The site is now occupied by Farnham Close.

Whetstone House stood next to Walfield until about 1987 when it was demolished and replaced by a block of flats called Walfield House. The main room downstairs had carved wooden panels in a rural attempt to imitate Grinling Gibbons. The Smith family lived here for many years.

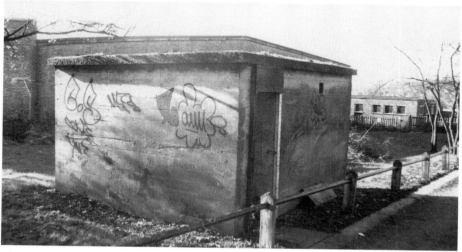

This air-raid warden's post still stands at Brook Farm. Such buildings were used as reporting centres for civil defence purposes during the Second World War. They measured 8 ft long by 6 ft wide by 8 ft high, and cost £59 each to build. The posts were sparsely equipped, each with three chairs, a table, a 15 watt bulb, a 40 watt radio, a 600 watt electric fire and a telephone.

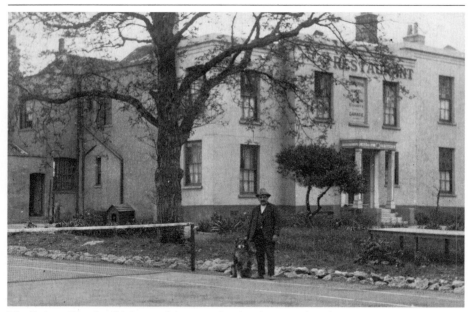

The Palace Hotel, which stood just south of today's Buckingham Avenue. Mr Osenda, the owner, is standing by the hotel's tennis court, *c.* 1925. Famous for its pasta, the hotel was very popular with London's Italian community. An elderly local resident remembers watching with amazement as people ate what he thought were lengths of string at the dining-table. The hotel was demolished in the early 1930s.

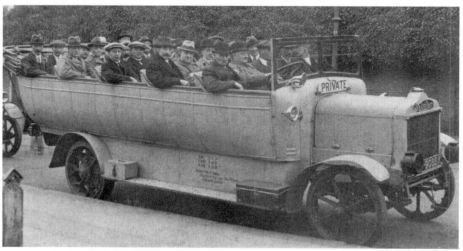

One of two charabancs all set to take 'the men of Whetstone' on a day trip in the twenties. (The second vehicle is just off the left-hand side of the photograph.) Typically, the women are left behind to look after the children, cook the dinner and do the housework. Perhaps the most significant social change in the last hundred years has been in the role of women.

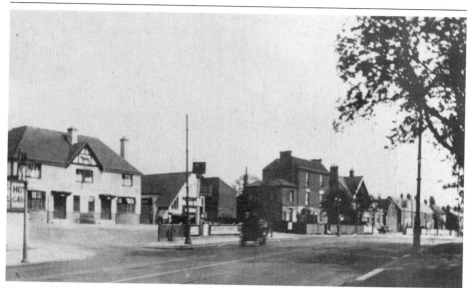

The Black Bull, from the north, in the 1930s. Originally called the Bull, the inn is first mentioned about 1780, and had fields attached so that drovers could stop overnight and graze their beasts. In the 1920s and '30s the pub was closely associated with the training of boxers. A gymnasium at the back was used by many famous men including the world champion, Jack Johnson.

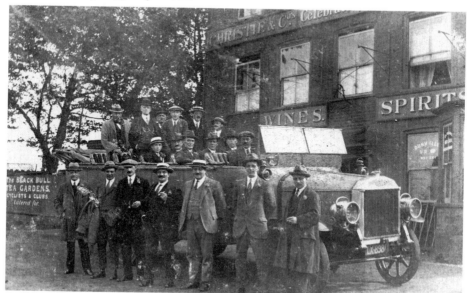

A group of regulars from the Black Bull, off to somewhere like Southend or Clacton in the 1920s. The inn in the background is the eighteenth-century building which preceded the present building.

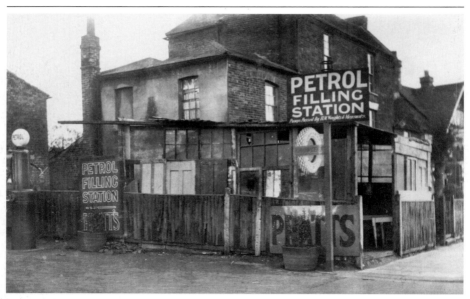

This old garage stood south of the Black Bull and used to be part of its stables. It is a reminder of the early days of motoring in the 1920s, when horse transport began to be replaced and petrol stations were still few and far between. It is now a Mobil service station.

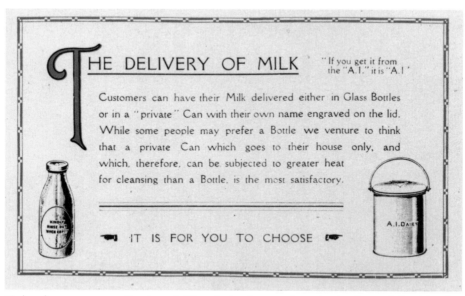

# THE DELIVERY OF MILK

"If you get it from the "A.I." it is "A.I"

Customers can have their Milk delivered either in Glass Bottles or in a "private" Can with their own name engraved on the lid. While some people may prefer a Bottle we venture to think that a private Can which goes to their house only, and which, therefore, can be subjected to greater heat for cleansing than a Bottle, is the most satisfactory.

☛ IT IS FOR YOU TO CHOOSE ☚

'A bottle or a personalized can? The choice is yours', as is clearly explained in this advertisement from a 1920 brochure. The introduction of bottles put an end to the milkman's traditional perk of fiddling the amount of milk poured into the cans. Bottles were also more hygienic and made production and distribution easier.

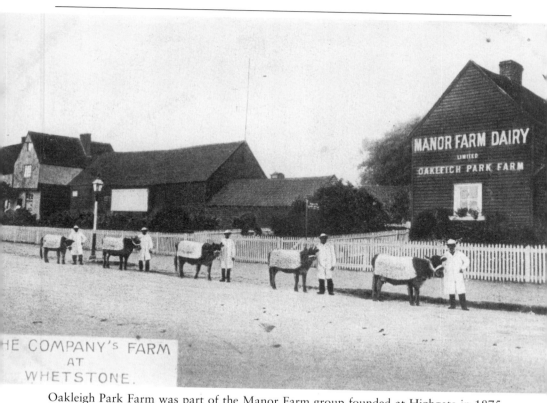

MANOR FARM DAIRY
LIMITED
OAKLEIGH PARK FARM

HE COMPANY'S FARM
AT
WHETSTONE.

Oakleigh Park Farm was part of the Manor Farm group founded at Highgate in 1875. Their fields extended over the area now covered by Buckingham, Temple and Chandos Avenues. The cows shown here had won prizes at a Smithfield Show in about 1900, hence the coat jackets on man and beast. The dairy became part of the United Dairies chain in the 1920s.

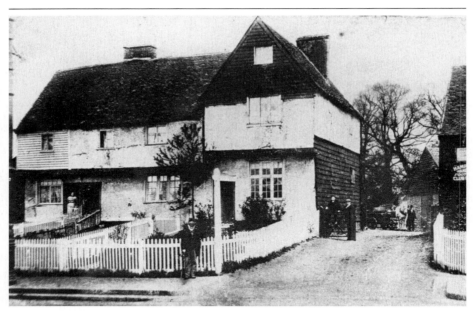

Blue House Farm, *c.* 1910. The Tudor origins of the farm building are shown by the steeply pitched roof, at right angles to the main building. The cottages are probably Georgian. The fields were mainly used for dairying, but Hampstead Wanderers Football Club, later to become Hendon FC, rented a field at the rear.

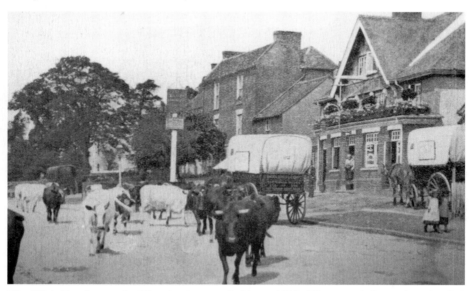

The High Road near the Blue Anchor, probably *c.* 1900. The cows belonged to the A.1 Dairies, founded by Mr de Rivaz, a respected and well remembered local employer. The animals are walking along the Great North Road on their way to be milked.

Brook Farm House, opposite the Black Bull, was demolished in 1914 just after this picture was taken. It stood on part of the former Finchley Common which extended as far north as the county boundary. In the 1880s it was owned by Mr Broadbelt who was also licensee of the Black Bull. The poster on the left advertises 'animated pictures'. The cinema was about to take off.

A very rare picture of Brook Farm House, from the rear. The building appears to date from the middle of the eighteenth century. Its owner, Mr Broadbelt, went bankrupt when an outbreak of anthrax caused the loss of all his cattle. The site is now occupied by the Express Dairies distribution centre.

Mr John Hall and his family, running to three generations, in the yard of the A.1 Dairies in the late 1930s. They are sitting on a horse roller.

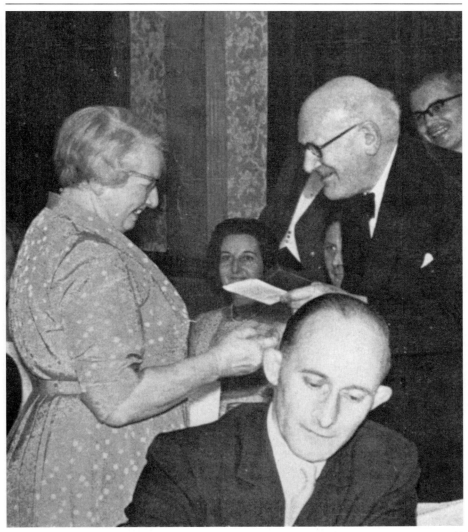

Mr Harold Freeth, chairman of the A.1 Dairies from 1950 to 1967, presenting a gold watch to Miss Kate Dennis, a former roundswoman. The headquarters of the National Dairymen's Benevolent Institution, Freeth House, is named in Mr Freeth's honour.

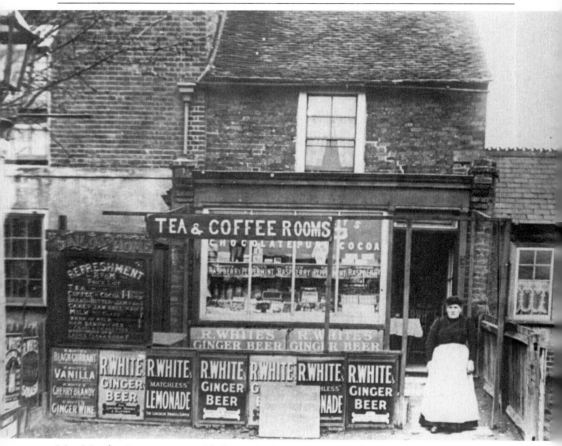

Mrs Martha Beaumont outside her refreshment rooms, adjacent to the Blue Anchor in the High Road, c. 1910. The family moved here about 1880. Mr Beaumont had been a sailor, hence the name 'Sailor's Home'. Among many other things, Mrs Beaumont served jugs of tea to passing tram drivers, who in the early days were not allowed a break and had to eat and drink while moving along.

Mrs Appleby's greengrocers shop, at the corner of Solomon's Terrace, *c.* 1905. Mrs Appleby always made a special display at Christmas. Today's by-laws and standards of hygiene would make such a pavement exhibition impossible. Mrs Appleby was also a skilled dressmaker, much in demand by local brides-to-be.

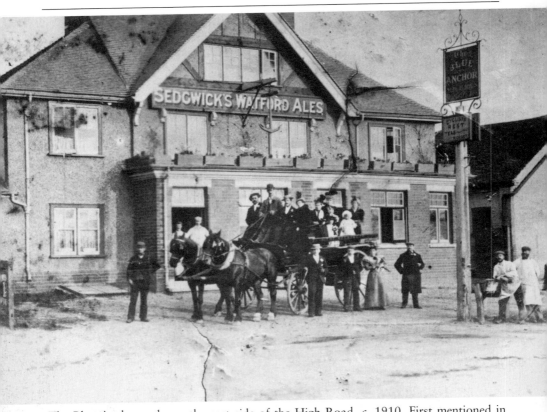

The Blue Anchor pub, on the east side of the High Road, *c.* 1910. First mentioned in 1772, when it was owned by John Sleath, the pub was demolished in 1983 to make way for the Payless DIY store. When this photograph was taken the pub catered for both local and passing trades, particularly cyclists. The straw hats, buttonholes and presence of women and children indicate that the party were setting out on a day's excursion to somewhere like Epping Forest.

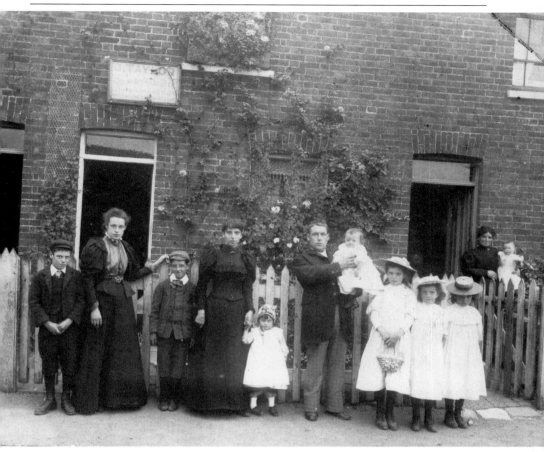

The Catchpole and Prockter families outside No. 3 Jacques Cottages in the High Road, 1896. The occasion was the christening of little Alfred Catchpole. Houses like these were built for rent by businessmen like Charles Jacques, who lived in Finchley. In 1896 they were rented at 5s (25p) a week.

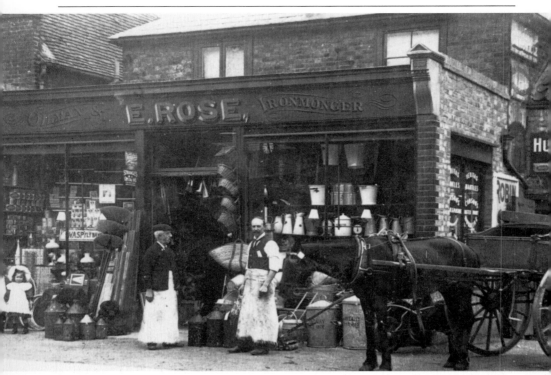

Rose's oil store (about No. 1,325), near Ivy House on the west side of the High Road, *c*. 1910. Mr Rose is in the centre, his son-in-law, Mr Oliver (who took over the business), is on his left and his two granddaughters are on his right. The shop was pulled down in the 1950s.

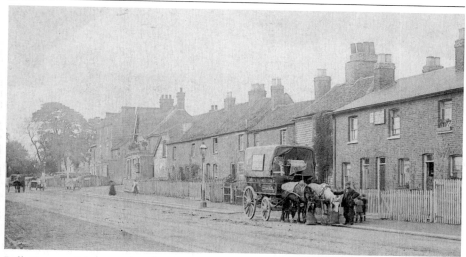

Bell Cottages, just south of the Blue Anchor, *c.* 1900. The notice on the cart reads 'Carpets collected and dyed' and refers to the Patent Steam Carpet Beating Company on Totteridge Green. John Taylor, the bricklayer, advertises his trade on a board on the wall of his house. This site is now occupied by Europa House.

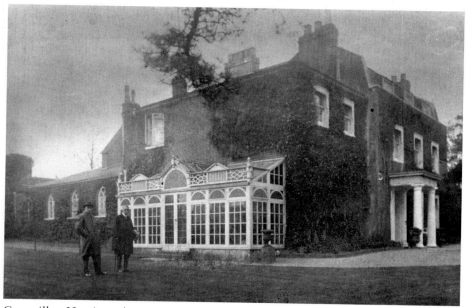

Councillor Harris and Mr Whittemore outside the Grange, 1932. This large mid-nineteenth-century house was used at one time as a private lunatic asylum. It was owned more recently by the Jelks family, famous for their furniture store, which was destroyed in the Second World War. The Grange was pulled down in 1938 and Grange View Road was built on the site. Houses on this road cost £1,250 in 1939.

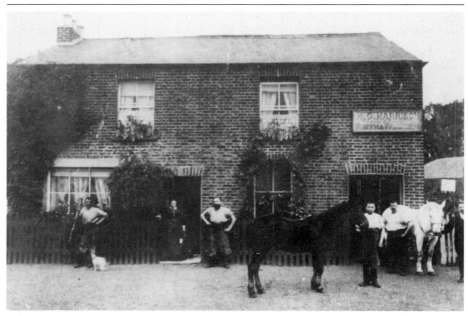

Harrison's forge, just south of Bell's Cottages, *c.* 1897. The smith is wearing his traditional heavy leather apron. The forge was later operated by the Lines family. This site was redeveloped by the National Provincial Bank on the corner of Chandos Avenue.

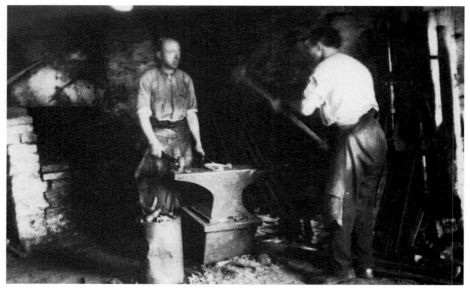

The last smith to operate a forge in Whetstone High Road was Harry Baldwin, seen here *c.* 1930. During its heyday the horse traffic going up and down the Great North Road provided work not just for smiths, but for a number of other skilled craftsmen.

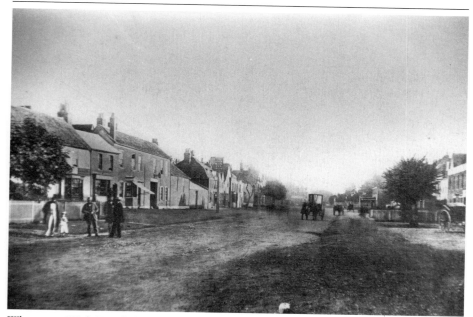

Whetstone High Road, looking south from today's St Margarets Avenue, c. 1870. The costumes indicate the early date of this fine photograph as does the unmetalled state of the road surface. Some of the trees which formerly lined the High Road can be seen.

St Margarets Avenue, looking south, c. 1930. This road is typical of the many developed in the 1920s before the widespread introduction of the motor car obliged every house to have its parking space or else to clog the streets with parked cars.

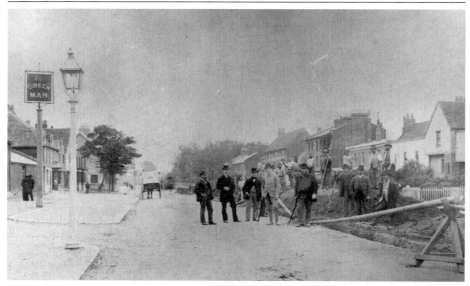

Pipelaying outside the Green Man in the High Road, c. 1870. Sewers were constructed in Whetstone in response to the Sanitary Act of 1866. The East Barnet Water Company extended its mains along the High Road and thence to Totteridge in 1870. However, not all houses had taps or stand-pipes, and wells continued in common use until the First World War.

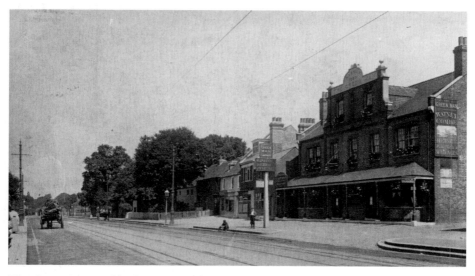

The Green Man public house, c. 1925. There has been a pub on this site since before 1485, when John Doggett sold a messuage called The Lion to Thomas Copewood. The pub was re-built about 1740, refronted in 1830 and again in 1891. It is now the Green Man Garage and cars are repaired in the former stables.

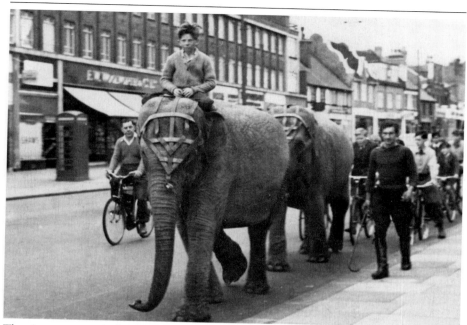

The circus came to Whetstone in 1951. Surprisingly the procession of elephants walking past Woolworths and the local tube station caused very little disruption to the traffic.

Smith's Cottages occupied Nos. 1,298–300 High Road. They dated from the time of Nelson and were timber clad as well as being timber framed. They were demolished in the late 1930s.

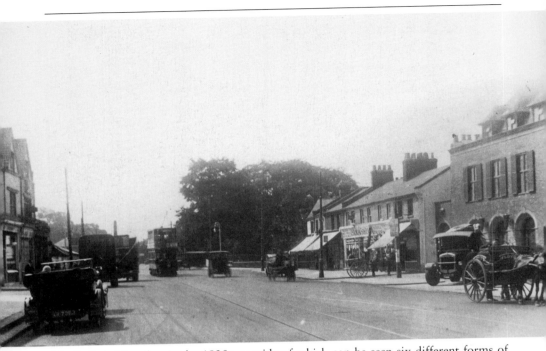

The Bull and Butcher in the 1920s, outside of which can be seen six different forms of transport. A passenger languishes in the rear seat of her open-topped car; an open-topped bus has just overtaken a parked lorry; the tram dominates the centre of the road – it has just been overtaken on the inside by a delivery van; another lorry is delivering beer; and a pony and trap stand outside the pub.

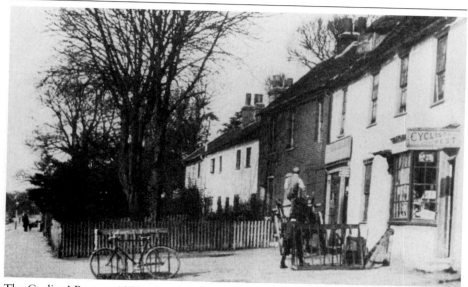

The Cyclists' Rest, c. 1902. The shop was later owned by Eddie Coulon for many years. The interior always gave the appearance of being disorganized, but if asked for a part, Mr Coulon would burrow into his mounds of bits, and return triumphantly brandishing what was sought. He also had a legendary knowledge of the form of the various racehorses currently running.

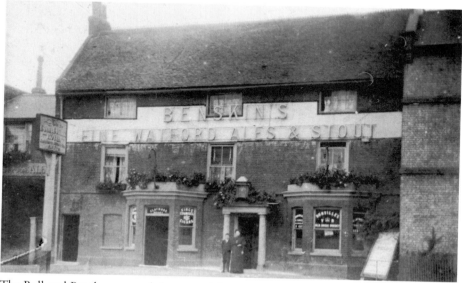

The Bull and Butcher, around the turn of the century. Pubs like this all had livery stables where a pony and trap could be hired, just as a minicab is hired today. The pub was called the Bull and Conjuror in 1731, and the first reference to a house on this site is dated 9 October 1375.

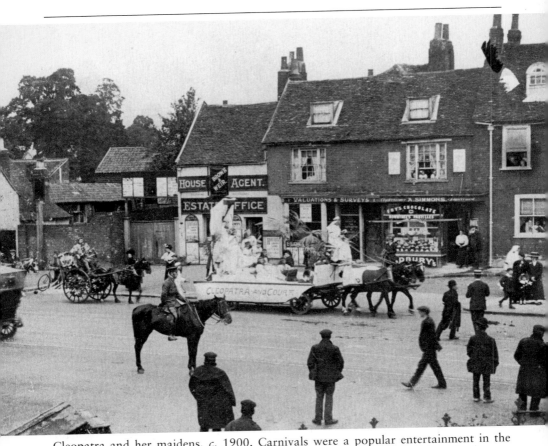

Cleopatra and her maidens, *c.* 1900. Carnivals were a popular entertainment in the early years of the century. Various firms vied with each other to produce the best or most original float.

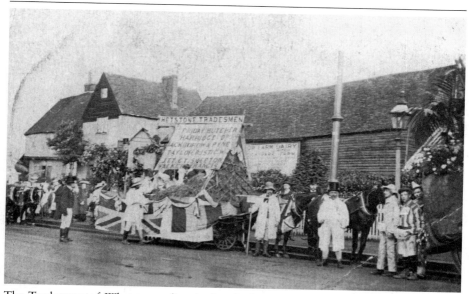

The Tradesmen of Whetstone, disguised as Robin Hood and his Merry Men, *c.* 1900. The Finchley Carnival still survives to remind us of the old custom.

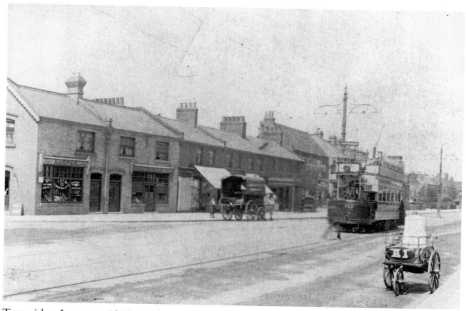

Totteridge Lane, *c.* 1910, with Harper's bakery on the corner. The open-topped trams had been running up to Barnet for about three years. The A.1 milk-float, a specimen of which can be seen in Barnet Museum, carries a milk churn from which milk was poured into the customer's own can or jug.

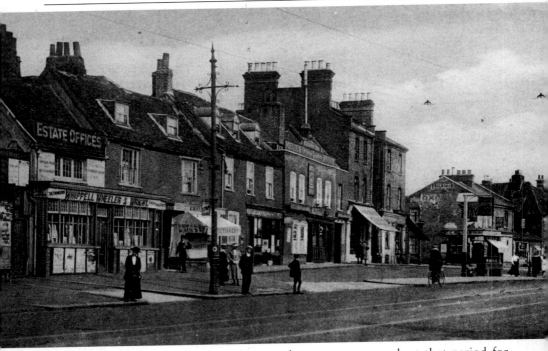

Whetstone crossroads, *c.* 1925. Photographs were rare enough at that period for everyone to stand and watch the photographer rather as we would watch a television crew today. E.C. Wilson advertises his shop on the far corner.

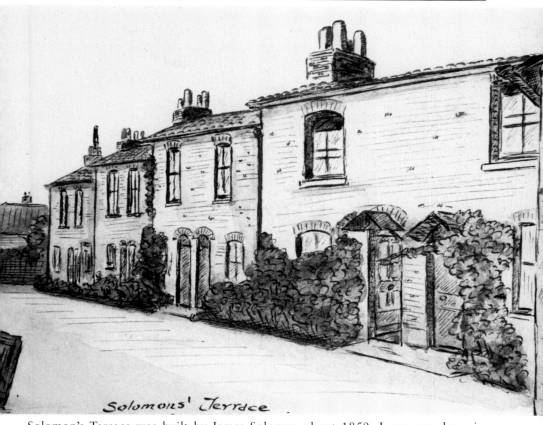

Solomons' Terrace

Solomon's Terrace was built by James Solomon about 1850. James was born in Donnington, Lincs., in 1816 and died in 1858. He had a general store in the High Road. His son, also James and nicknamed 'King Solomon', was successively publican of the Bricklayers Arms and the Bull and Butcher. The terrace was demolished about 1955 to make way for a post office.

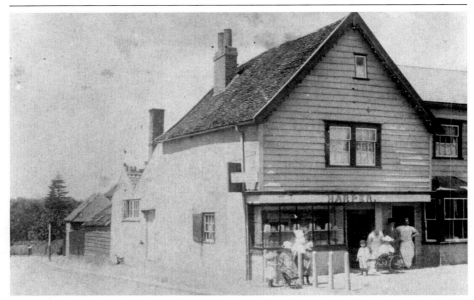

Harper's bakery on the corner of Totteridge Lane and the High Road, *c.* 1875. An early gas lamp can be seen just down the lane. Gas mains came to Whetstone about 1862 and the number of street gas lamps increased from forty-two to eighty-seven between 1884 and 1885, though, in order to save cost, they were not to be lit on moonlit nights!

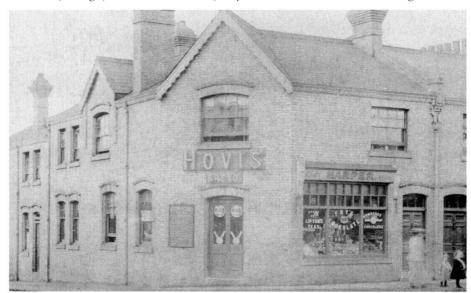

Harper's old bakers shop was rebuilt about 1880. There had been a bakery on this site since before 1819. It is now owned by Hillside Bakery and is due for demolition shortly. Some of the old ovens still exist at the rear.

Whetstone crossroads, from the west, *c.* 1880. The Gilmour family can be seen outside their shop. Robert Gilmour ran a draper's business in 1840 and was also the last keeper of the toll-gate. After the gate was removed in 1863, he took over the post office, which two of his daughters continued to run until 1938. It was said that no postcard was delivered in Whetstone unless the Gilmour sisters had read it first. The man on the right is sitting on the old stone, which at that time stood much further back from the road than it does today.

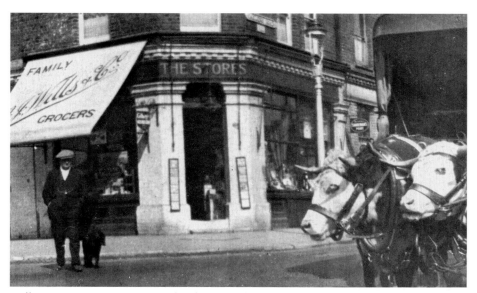

Wills Grocery Store, *c.* 1937. The shop stood at the corner of Oakleigh Road for many years. The two oxen were used both as a publicity stunt to advertise Atora Beef Suet and for pulling the delivery cart. The shop is now a restaurant.

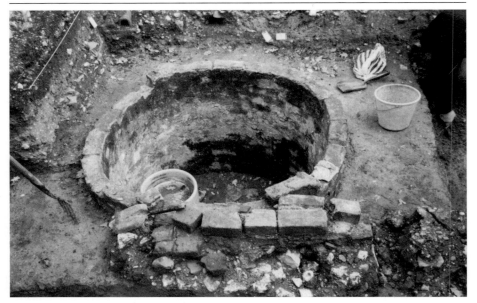

The back garden of No. 1,264 High Road, where excavations in 1990 revealed Tudor foundations (front of picture) and a large Victorian cistern. The house itself has erroneously been called the oldest in the district. In fact it dates from about 1505. The front part, dating from about 1750, was used as a post office until 1938 and more recently as Studio Cole.

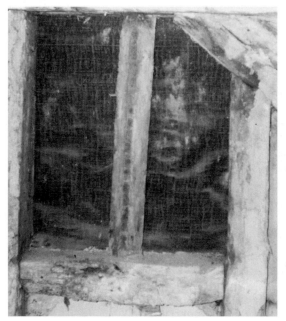

The rear of No. 1,264 High Road. This window has a diamond-shaped mullion typical of the Tudor period (*c.* 1505) and probably belonging to the original house.

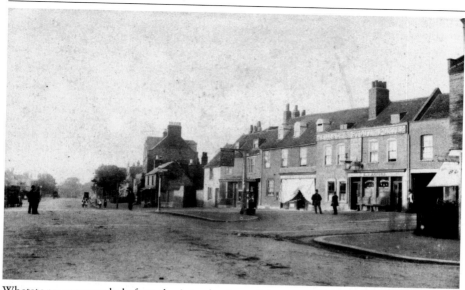

Whetstone crossroads before the introduction of gas street lamps, *c.* 1875. The Hand and Flower pub on the right-hand corner was once called the Black Horse, and what is now Oakleigh Road was called Black Horse Lane until about 1875. On the other corner is the Griffin, first mentioned as a pub about 1694. It was rebuilt in its present form in 1929.

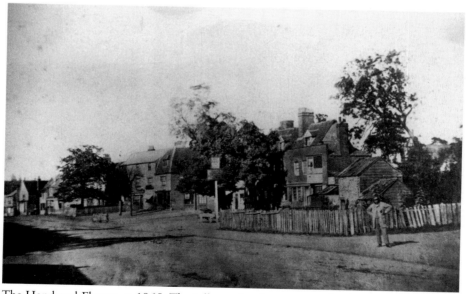

The Hand and Flower, *c.* 1865. The toll-gate has been removed. The man in the picture is thought to be Robert Gilmour. Elm trees said to have been planted by Richard Attfield about 1800 were a feature of the old High Road.

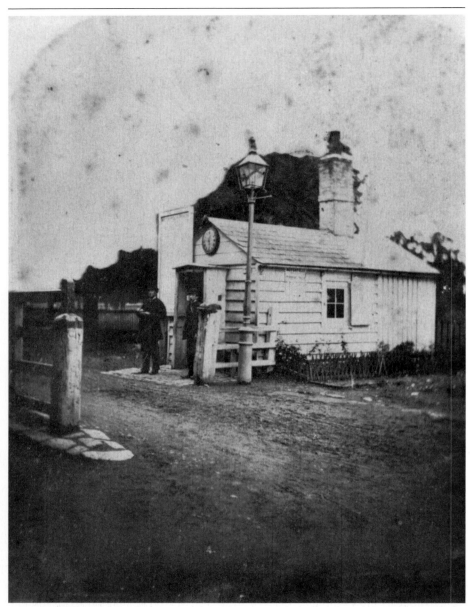

The Whetstone and Highgate Turnpike Trust was formed in 1712 with the object of improving an 8 mile stretch of the Great North Road. Finance was raised by charging tolls to pass through a gate. The gate at Whetstone stood at the crossroads outside the Griffin Inn. Other gates were at the Woodman, Highgate, at the foot of Barnet Hill and at Ganwick Corner near Potters Bar.

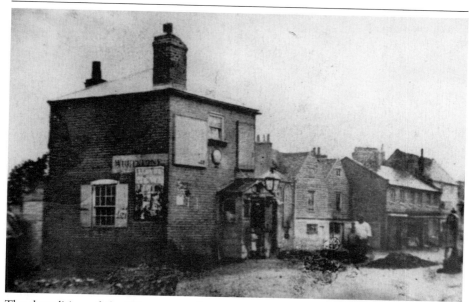

The demolition of the Whetstone toll-gate, October 1863. The workmen are mending the hole in the road created when the gatepost was removed. The last surviving Trustee was Joseph Baxendale.

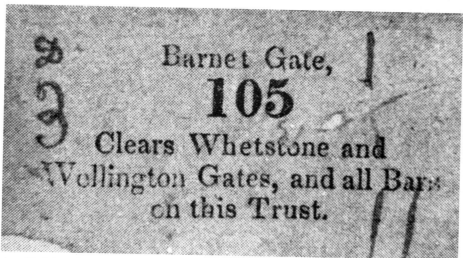

A toll ticket from the Turnpike Trust, dating from about 1805. Such tickets are extremely rare these days, and this is the only specimen known to the author. There was a weighbridge in front of the Griffin, and in 1806 the operator was sacked for letting his pals through at a reduced rate.

An aged Joseph Baxendale sits in his donkey cart with an attendant groom in the grounds of Woodside House, *c.* 1870. Joseph was born in Lancaster in 1785 and moved to London in 1806 where he took over the then ailing transport firm of Pickfords. He made this into a great success. At its peak the firm employed 1,000 men and 2,000 horses. He bought the Woodside estate in Whetstone in 1824 and built Woodside House on it.

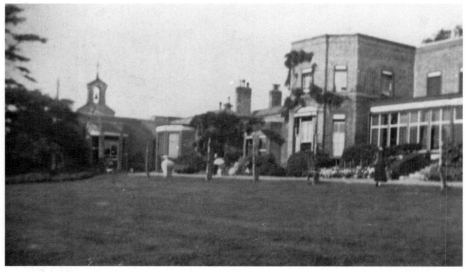

Baxendale's house at Woodside on the corner of Totteridge Lane, *c.* 1890. By the turn of the century the house was used as a retirement home for 'Ladies', who occupied the lower floor, with their maids using smaller rooms on the floor above. The house was used by the police during the Second World War and has been replaced by a modern retirement home still called Woodside.

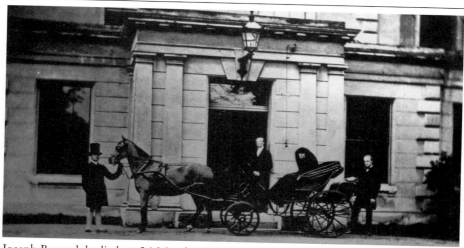

Joseph Baxendale died on 24 March 1872. Here his sister, in full Victorian mourning, is returning from the interment in the family vault underneath what was then the altar of St John's church.

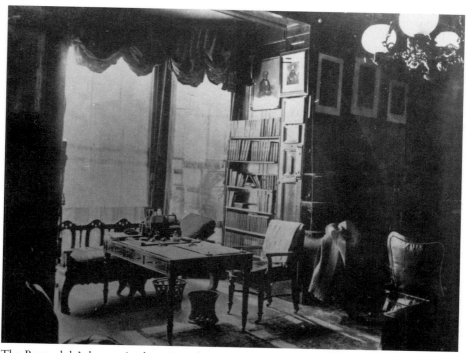

The Baxendale's house, in the spirit of the times, *c.* 1870, was furnished in the height of luxury. The library has 'elephant's drawers' curtains, leather armchairs and three gaslit globes. The Woodside estate had its own gasometer in Totteridge Lane, which was demolished to prevent its being blown up at the time of the Fenian outrages.

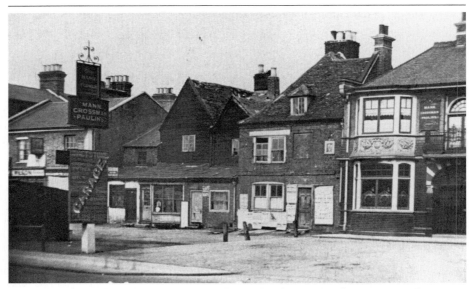

The restored Hand and Flower, on the right, probably shortly after it reopened in 1905. The adjacent wooden buildings seem to date from about 1730. The small building (bottom left) was a so-called 'coffee shop', where hot drinks and snack food was available at a very low cost.

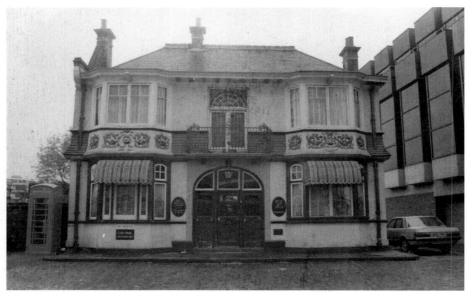

The Hand and Flower just before demolition at the end of the 1980s. The pub was rebuilt in 1905 with ornate plaster work typical of the Edwardian period. The whole site is now covered by Barclays Bank.

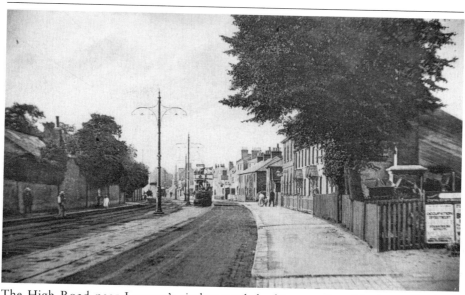

The High Road near Lawson's timber yard, looking north, with the wall of the Woodside estate on the left, c. 1910. The row of houses on the right was Oakley Buildings, demolished in the late 1980s. The blue lamp of Whetstone's first police station (opened 1861) can be seen just opposite the open-topped tram.

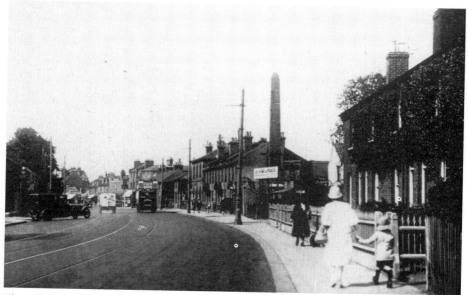

The High Road, again looking north, from just south of Lawson's, c. 1930. The tall chimney conducted noxious gases from the sewers under the High Road. It was 'flared' on occasions, ignition being controlled by a gas valve.

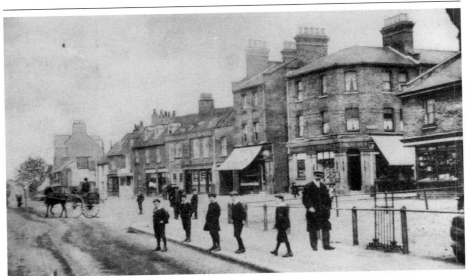

Presumably this photograph was taken on a Sunday morning at the turn of the century, when it was common for church choirboys to wear Eton collars. The boys were paid 2s (10p) a quarter for two services each Sunday and two practices a week. It was a much sought-after way for young lads to earn some pocket-money.

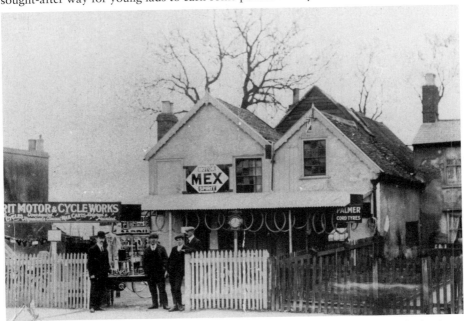

The Merit Cycle and Motor Works, shortly after the turn of the century. The business occupied what was later to become Lawson's timber yard. Palmer tyres, mentioned in the small advertisement, were highly regarded by many cyclists in those days.

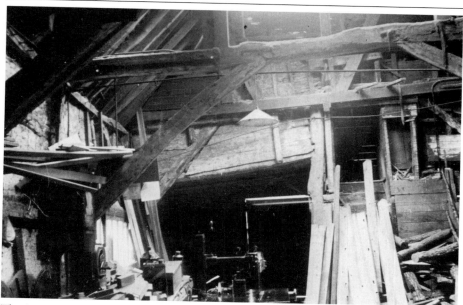

The interior of one of Lawson's buildings, *c.* 1936. Here old packing cases, logs and other scrap timber from London Docks were cut up for kindling wood. Coal fires needed thin wood to start them off. This building was probably erected, as a wheelwright's, by Thomas Hunt about 1745. Some of the massive timbers were reused from other buildings, and possibly even taken from old ships.

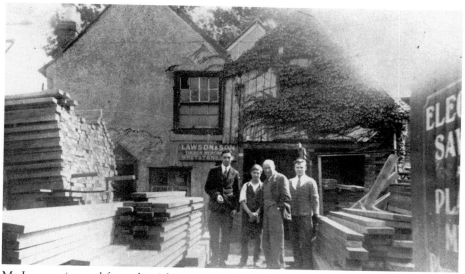

Mr Lawson (second from the right) stands in his timber yard, *c.* 1936, which he opened in 1921. The buildings at the back were demolished in the early 1990s. The company still occupies the site today and is a leading manufacturer of fences, garden sheds and furniture.

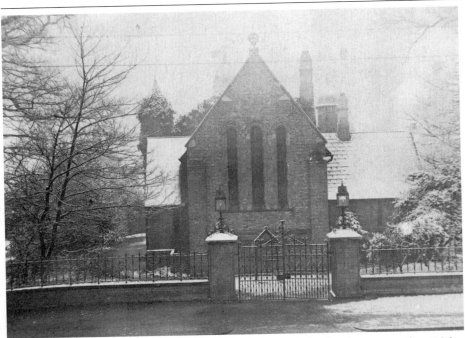

St John's church was built on a corner of Joseph Baxendale's land and consecrated on 9 May 1832. The architect was almost certainly Bishop Blomfield of London. The church was enlarged in 1879 when a window described as 'School of William Morris' was installed.

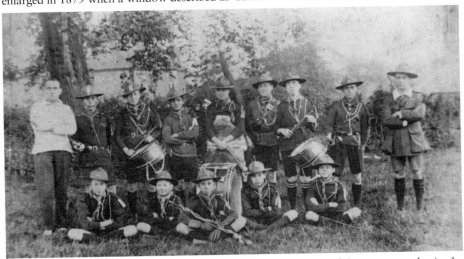

The 93rd North London (St John's) Scout Troop, *c.* 1915. One of the most popular in the area, the troop had its own band with instruments bought with the proceeds of concerts given at Woodside Hall. Several of the troop served in the First World War with distinction, with Vic Vincent helping the coastguard and later becoming an international athlete.

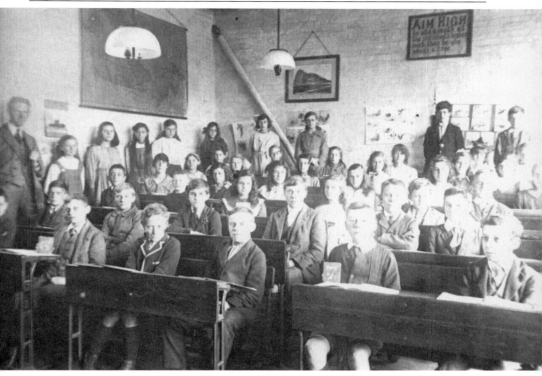

Mr Mellor, at this time the headmaster, with pupils of St John's School, 1914. The school was founded about 1833 in a room next to the stables of Baxendale's estate in Totteridge Lane. It moved to Britannia Road in 1863 and to its present position in Swan Lane in the 1970s.

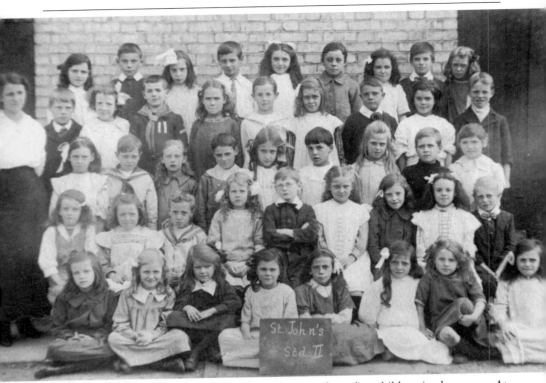

Standard Two at St John's School, 1919. There are forty-five children in the group. At the end of each year the children were tested and those who were 'up to standard' moved up a class and those who were not suffered the ignomy of 'staying down'.

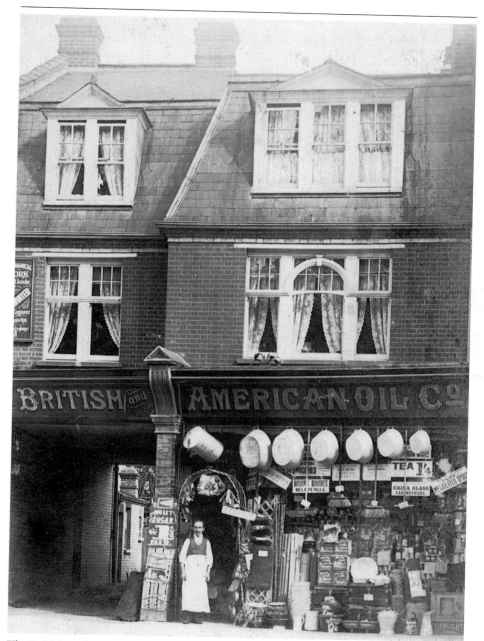

The British and American Oil Company's shop, *c.* 1910. The shop stood in the row of shops near the corner with Friern Barnet Lane. Establishments such as these sold a huge range of items, not least of which was whale oil and paraffin for lighting and heating, as well as more general groceries.

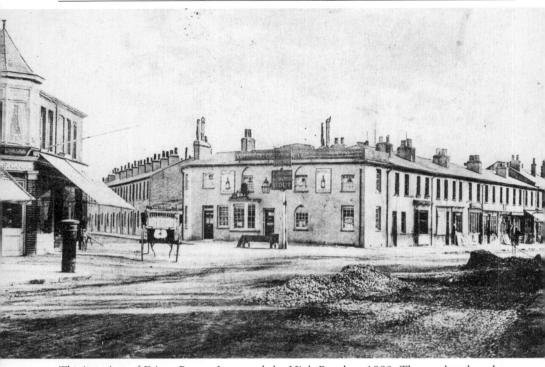

The junction of Friern Barnet Lane and the High Road, *c.* 1890. The road makers have left their pile of gravel unattended. The cart stands outside Cook's, a local baker's shop for three generations, who had started business as corn chandlers in Chipping Barnet.

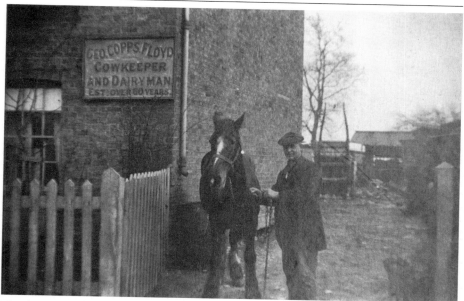

Floyd's Dairy Farm in the 1920s. The farm stood where today's police station stands in Friern Barnet Lane, and was typical of the many small dairy farms which served the area. The man is Robert Floyd, who committed suicide when his farm was sold to the United Dairies.

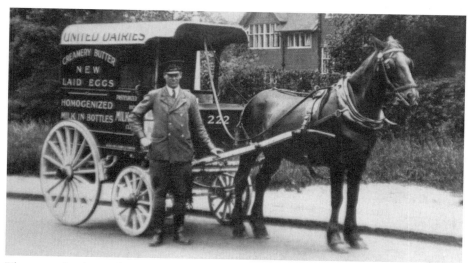

The smartly dressed milkman standing by his horse-drawn milk-float is Harry Broadbelt, who originally farmed Floyd's Dairy with his uncle, Robert Floyd. Following the sale of the farm to the United Dairies, Harry joined the army as a guardsman and later became a local policeman. His last job was as train-bearer to the Lord Chancellor of England, in which capacity he attended all the great State occasions.

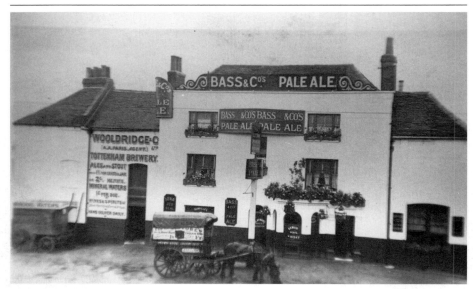

The Swan with Two Necks, *c.* 1910, is a corruption of the Swan with Two Nicks, a reference to swan upping. The pub was built by Edward Hartwell about 1728, pulled down in the 1960s and replaced by South and North Court. In the 1860s it was owned by Robert Lloyd, one of the last stage-coach drivers, who retired and used his knowledge of horses to run a pony and trap hire business.

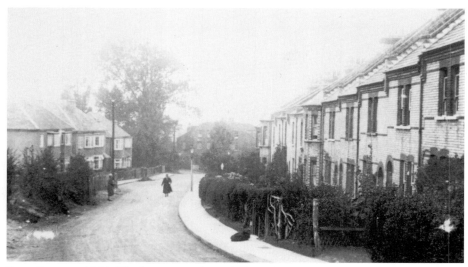

Swan Lane, *c.* 1930. The houses on the right have been demolished to make way for St John's School. Swan Lane gets its name from the Swan with Two Necks pub, which formerly stood on the corner with the High Road.

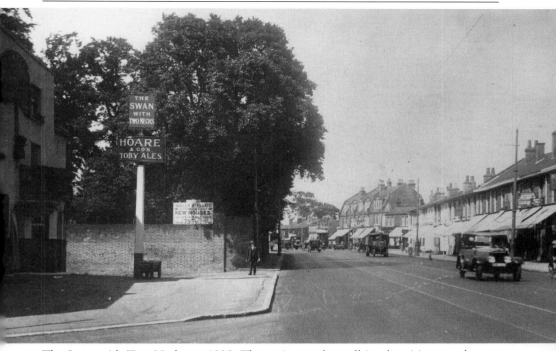

The Swan with Two Necks, *c.* 1923. The notice on the wall is advertising new houses for sale on the Birley Road estate from £795. The Birley family were cousins of the Baxendales and the estate was opened up after Joseph Baxendale's death in 1872.

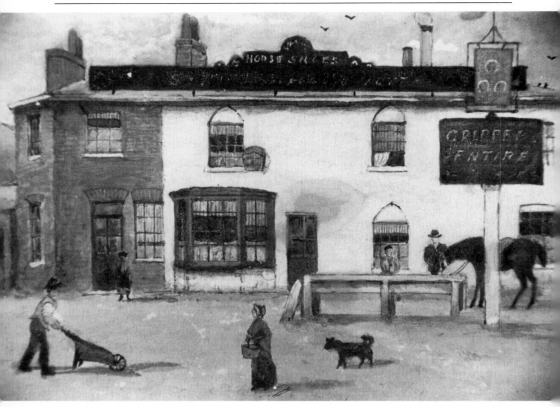

An undated painting of the Three Horseshoes on the south corner of Friern Barnet Lane. On the old maps this area is shown as Finger Post Corner. The Copps family lived in and operated the pub from 1881.

Spring and Egremont Cottages, on the east side of the High Road, c. 1947. As more and more affluent men moved into and built larger houses in the district, so smaller houses like these were built for their servants to live in. The Iceland store now occupies the site.

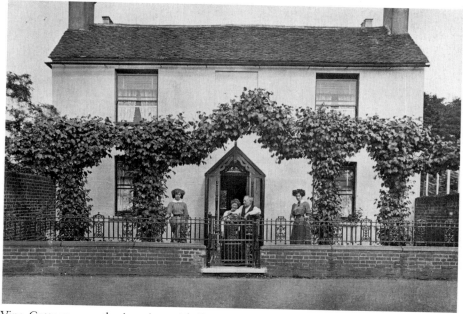

Vine Cottage near the junction with Rasper Road, c. 1910. The cottage got its name from the plant in the greenhouse just seen on the right of the house. Frank Aylmer, seen here, was a professional gardener, hence the ornamental trees. His daughters were said to be among the most attractive young women in Whetstone.

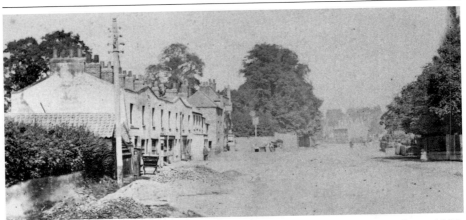

Whetstone High Road near the junction with Green Road, looking north, *c.* 1880. Whetstone Place is on the left and York Villa, Seymour Cottage and Ivy Cottage are on the right, behind the trees. The latter was the home in the 1860s of James Stanford, an officer of the Bow Street Horse Patrol, who kept his horse in a stable at the back. The pile of gravel in the foreground would have come from the gravel pits behind Whetstone Place in what is now Swan Lane Open Space, and was used to repair the road surface.

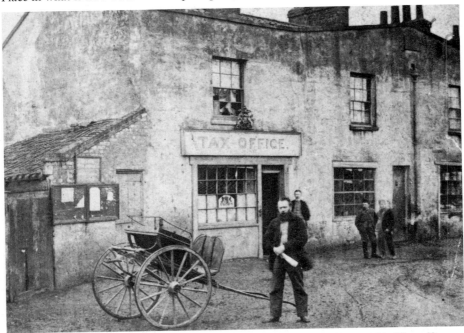

Joseph Hawkins, the tax collector, outside Whetstone tax office, *c.* 1880. The office, at No. 1 Whetstone Place, was built as Lynn's Rents about 1840. Joseph collected rates and excise duties. Income Tax was seven pence in the pound, but most local residents were too poor to pay it.

On Saturday 20 May 1939, as part of the training for war, a Blenheim light bomber flew over Whetstone High Road in a simulated bomb run. Whetstone Place, a terrace of old houses, was set alight in order to practise fire-fighting and rescue techniques. Unfortunately it was some time before a satisfactory blaze could be established.

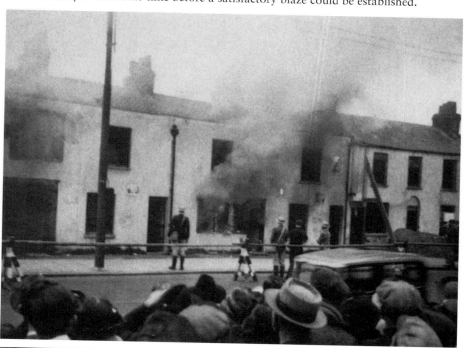

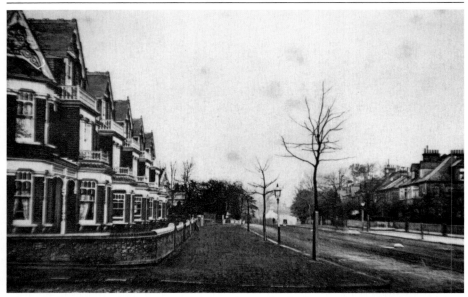

The junction of Woodside Lane and the High Road. The houses on the left were built in 1904 and the trams came through in May 1905, so this picture must have been taken between those dates. The pargeting on the houses on the left differs from house to house and it makes this one of the most attractive terraces in the district.

The High Road opposite Woodside Lane, *c.* 1908. The policeman reminds us of the Bow Street Horse Patrol, the predecessors of the Metropolitan Police, whose duties included visiting every public house on their beat on every tour of duty.

Chandos Avenue, developed gradually from 1910 onwards, gets its name from the Chandos family, Dukes of Buckingham, who bought 50 acres of fields here in 1791. They had a sumptuous mansion at Cannons near Stanmore and Handel wrote the Chandos Anthems to be performed in the chapel there.

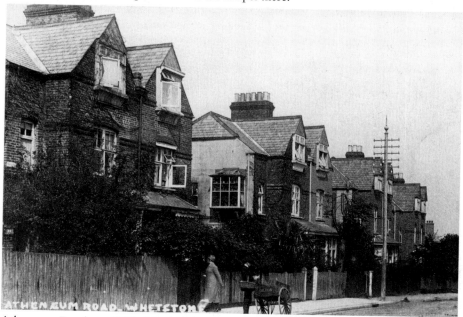

Atheneum Road, c. 1910. The lad from the oilman is arranging the orders he has to deliver. The road (called East Lane in 1485) gets its name from the Whetstone Atheneum Club, founded by George Waterlow in 1880 in what had been farm buildings. The club had a hall seating 400 with kitchens attached, a billiard room and lawns for tennis and croquet. After Waterlow moved to Sudbury in 1885, the buildings became a photographic works, and in the 1930s the Direct Dry Cleaners used them. The site is now The Firs and Cedar Court.

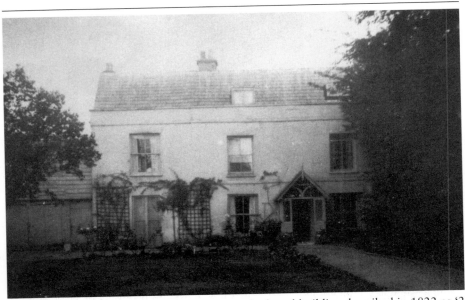

Coldharbour, now Mills Shop Fitting, is a much altered building described in 1822 as '2 houses, formerly one, known as the Dog and afterwards as the Queens Head, lately converted into two private houses with barns and stables'. The site is first mentioned in 1614, when the rates were twenty (old) pence a year.

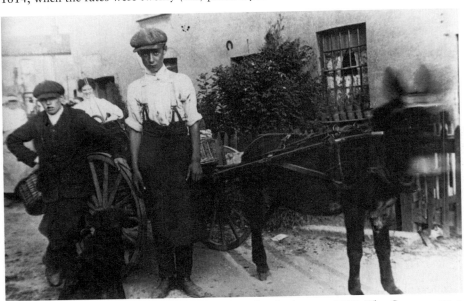

The Cooper family's donkey cart laden with wicker baskets, c. 1910. The Coopers ran a small grocery shop at No. 5 Whetstone Place in the High Road at the turn of the century. Daily delivery was an important part of the service expected by their customers.

# SECTION TWO

# Around Oakleigh Road

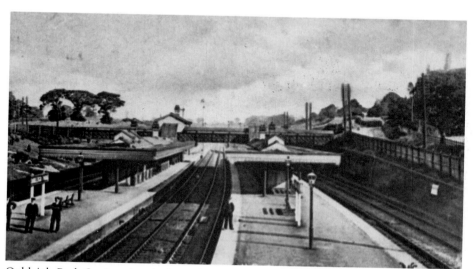

Oakleigh Park Station, just before 1905. This station was opened on 15 May 1873 to serve the new housing estate from which it got its name. Originally there was only one platform; a second one was built when the lines were quadrupled about 1890.

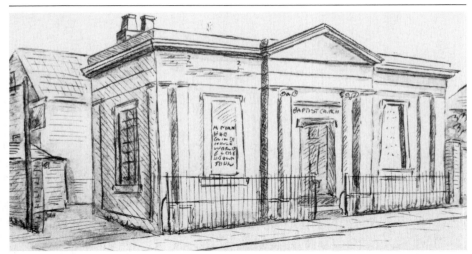

The old Baptist church in Oakleigh Road, c. 1947. Until 1950 the church occupied the site where the post office yard is now situated. It was built as a schoolroom by J.H. Puget and was used for girls and infants until 1904. The boys were educated in a separate building behind the chapel in Totteridge Lane. When the girls' school closed in 1904, the head teacher, Miss Mehaffy, had completed over thirty-nine years' service, but was just thirteen weeks short for a pension. She got twelve weeks' work in another school, but the education authority decided not to exercise discretion and grant her a pension because it might create a precedent – a meanness worthy of recording for posterity.

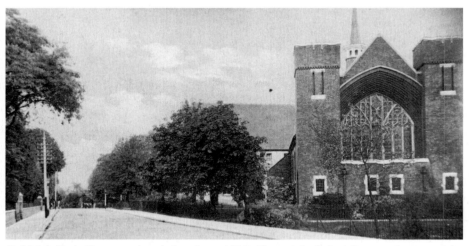

Oakleigh Park Congregational church, c. 1935. The original church opened to serve the new estate on 2 May 1888. It stood to the rear of the building shown here and cost £4,200. The church was burned down on 8 January 1900, and replaced by this building, which was opened in June 1901. At the opening ceremony, Mr W.H. Brown said that only £207 was still owing, and that if £107 was raised that evening, he would contribute the remaining £100. The collection raised amounted to £107 15s 8d.

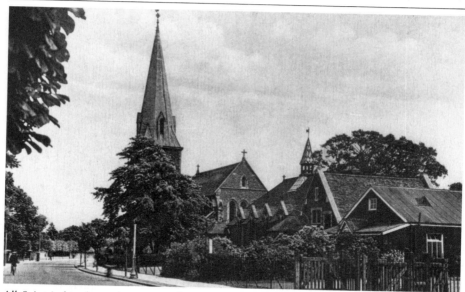

All Saints' church on the corner of Myddleton Park and Oakleigh Road, c. 1920. Built in 1881 with money provided by John Miles, the church served the affluent Oakleigh Park estate. The first vicar was the benefactor's son, Henry Miles, who, in those days of nepotism, was appointed strictly on merit. The vicarage (see below) can be seen in the background. Father Cameron succeeded Miles as vicar in the early 1930s.

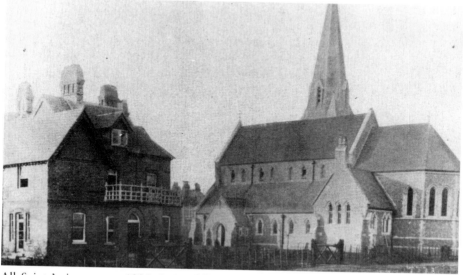

All Saints' vicarage, c. 1885, in Myddleton Park was pulled down to make space for Cameron Court. At the turn of the century many parishioners were grindingly poor. In 1884 the vicar's wife arranged to provide local children with 'a good nourishing meal' for a penny. This was served from the vicarage kitchen door.

Father Henry Miles was the son of John Miles. Father Miles was vicar of All Saints' from its opening in 1881 until 1932, when he was succeeded by Father Cameron. The Miles family were considerable benefactors at a time when poverty was rife. John Miles gave the money and land for three schools: St James' Infants' School in Sherwood Street, St James' Boys' School in Friern Barnet Lane and All Saints' Girls' School in Oakleigh Road. He also put up the money to build All Saints' church and to restore St James' church. Miles Way on the Russell Lane estate is named after him.

John William ('Bill') Thatcher was verger at All Saints' for over fifty years from 1911. He was said to have had a way with boilers 'that made them purr'. If he approved of a new curate, the latter would be called 'the young governor'.

Oakleigh Infants' School, *c.* 1936, in Oakleigh Road North was opened in 1928. It was the first state school built in the district. The head teacher was Miss Mellish. With the aid of one other teacher (straight from college) she looked after ninety-five children. The building was incorporated into All Saints' JMI School in 1969.

A class at Oakleigh Infants' School in 1936. In spite of the depression, these children look better clothed and nourished than their Victorian predecessors. Miss Mellish (top right) taught the top class full time as well as being head teacher.

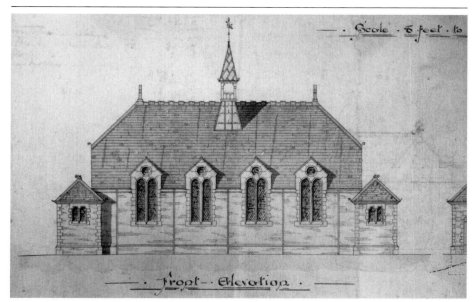

The architect's drawing of All Saints' Girls' School in Oakleigh Road, which opened in 1881. At that time, girls left school in Standard VII aged about 12 or 13. Most of the girls went into service, but some would go to work in the family shop or on the land.

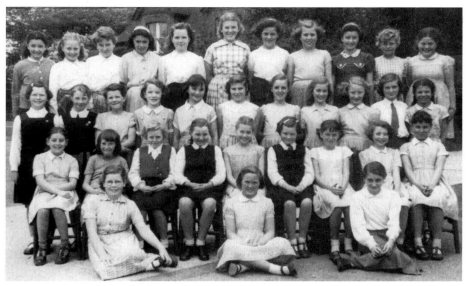

All Saints' girls, c. 1950. This group seems happy and well nourished, particularly when compared with school photographs of fifty years previously. When this school was amalgamated to form All Saints' JMI School in 1969, the building was taken over by a youth club.

Myddleton Park, shown here about 1904, consisted of a few houses near Oakleigh Road and then a stile leading to Friern Barnet Lane. The estate was sold by the Miles family in 1904. John Miles (see also p. 99) was a director of the New River Company founded by Sir Hugh Myddleton about 1610.

The Myddleton Park estate, consisting of Pollard and Loring Roads and Queens Avenue, has developed gradually since 1910. Pollard Road is built on an old field called 'Titramobs'. Nothing is known of the origin of such an unusual word.

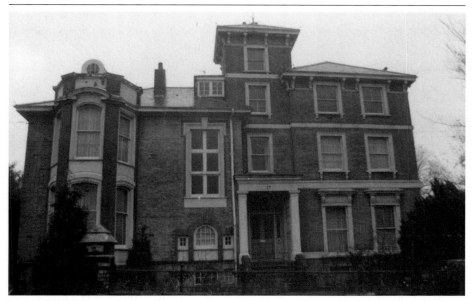

No. 19 Oakleigh Park North. This house was pulled down in 1994. It had been built in 1870 at a cost of £1,370, and was originally called The Acorns. It was too big for family occupation and was used as a school for many years. In 1939 it housed an auxiliary fire station and later was sublet as offices. The estate, built on Matthew's Farm, was sold to the Whetstone Freehold Estate Co. in 1869 by the Haughton Clarke executors. There was an agreement with the Great Northern Railway that they would build a station as soon as twenty-five houses had been completed on the estate.

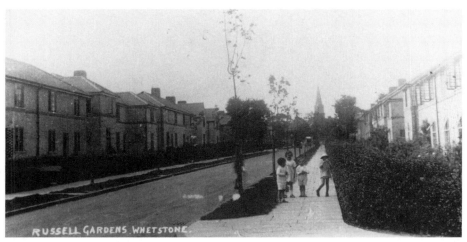

RUSSELL GARDENS WHETSTONE.

This picture is wrongly titled and is of Russell Road, looking south-west from the corner of Simmons Way, in the 1920s. Most of the children from this council estate would have been christened at All Saints' church, whose spire can be seen in the background.

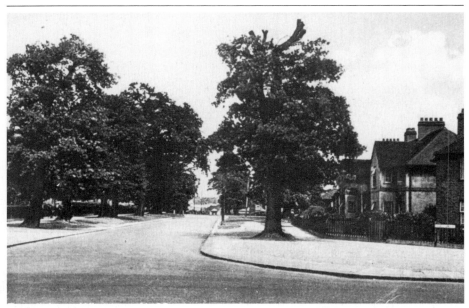

The junction of Russell Lane with Oakleigh Road North, *c*. 1930. The council houses flanking both sides of the lane were built in the early 1920s to provide much needed affordable accommodation for Whetstone's growing population. Surprisingly, most of the oak trees still survive.

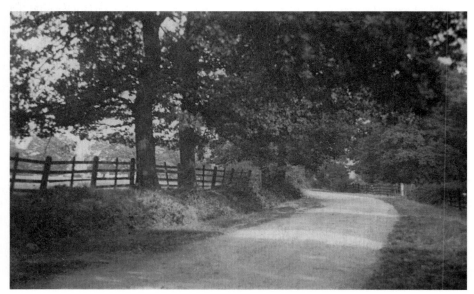

The north-eastern end of Russell Lane shows the essentially rural character of the whole district a hundred years ago. This is now a notorious traffic run.

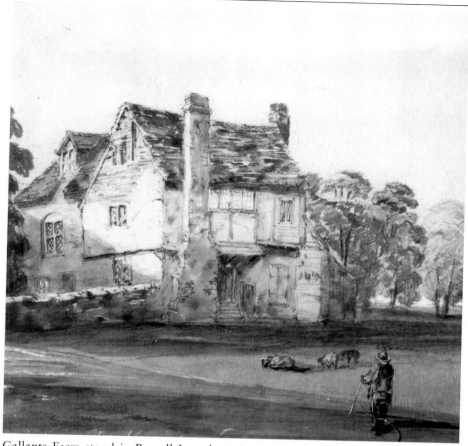

Gallants Farm stood in Russell Lane between Beresford and Wierdale Avenues. An earlier name was Gillants Farm. The 45 acres of farm land were sold in 1934 for £45,000 to provide space for the Gallants Farm estate.

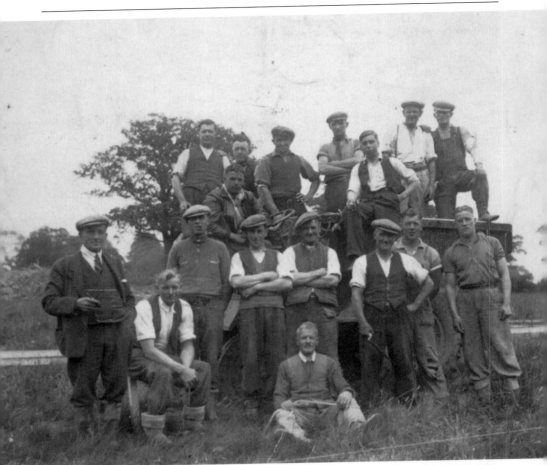

A group of builders involved in the construction of the Gallants Farm estate, built about 1935–6. The group includes two generations of Rebouls who were bricklayers. The estate was built by the Ideal Homes Company, who instructed their workers to use the best materials and to work to the best standards. The houses and bungalows were sold from £695 or rented for £1 19s per week.

Today's Russell Lane was imaginatively constructed on either side of the original lane. The shops shown here were built to serve the new estate.

The Cavalier in Russell Lane, *c.* 1950. The pub was built as an essential part of the Gallants Farm estate. One would have expected the bricklayers to build the pub first, but in fact it was one of the last things on the estate to be finished.

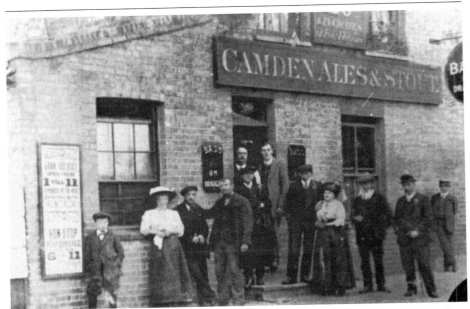

Mr Bass's beer house, *c.* 1905. This is now the Rising Sun in Oakleigh Road. Mr Bass (no relation to the brewer) also owned a couple of cottages where Petty Things is now.

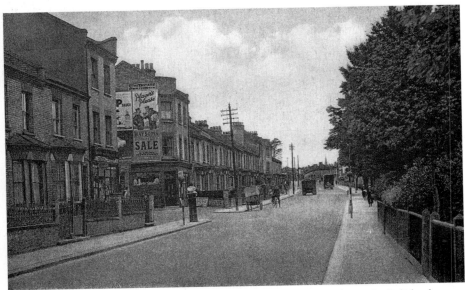

Doncaster Terrace was built in Oakleigh Road about 1875. The early Belisha beacon dates the picture to about 1936. A feature of the terrace is the corner shop, built one storey higher than the other houses to provide accommodation for the family.

Smith's Cottages at the northern end of Russell Lane, *c.* 1905. Still standing today, the cottages were built about 1870 for the Smith sisters, who owned a smallholding opposite. Situated approximately where Barnet College now stands, this smallholding became a pig farm during the First World War.

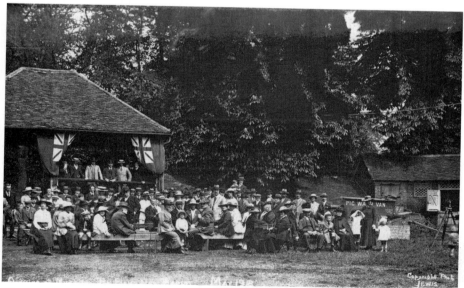

The opening of Russell's Pig Wash Farm in May 1918. The effects of the German U-Boat campaign caused the home production of food to be encouraged. Scraps were collected in special pig food bins and fed to the animals to fatten them up. We assume that these people were offered something more appetizing.

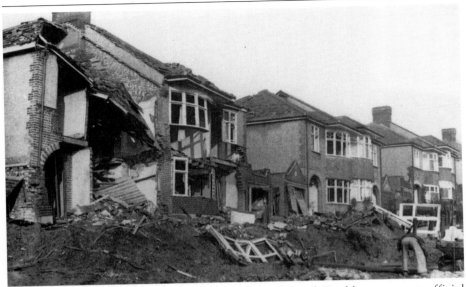

Bomb damage in Osidge Lane, *c*. 1944. Whetstone and Finchley were not official evacuation areas. They were considered to be 'safe'. Some bombs did drop however. The crater made in Osidge Lane was said to be big enough to hold a double-decker bus.

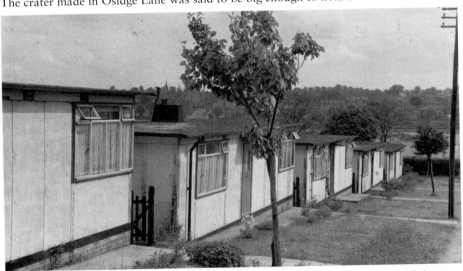

'Pre-fabs' in East Crescent, *c*. 1950. In 1946 two problems arose as a result of the war: first, a national shortage of houses caused by bomb damage and the absence of new building during the war; and secondly, a national aluminium industry suddenly facing the prospect that nobody wanted to make war planes any more. Prefabricated buildings made out of aluminium panels were developed in Canada. They were well equipped inside and proved very popular with those who lived in them. Although they were intended only to last for about ten years, they were very durable and some have lasted until the 1990s.

# SECTION THREE
# Around Totteridge

Totteridge crossroads at the turn of the century. Barnet Lane, coming in on the right, is one of the oldest roads in the district. When the church was under the control of the Bishops of Ely in the Middle Ages, the lane was used, until 1562, as part of the bishops' route through Barnet and Hatfield to both Totteridge and Westminster.

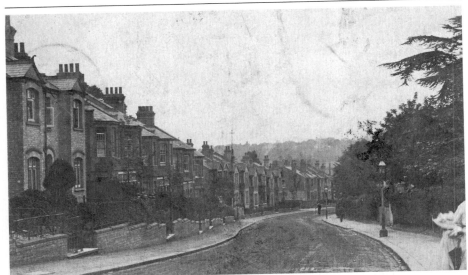

Totteridge Lane, looking west from the High Road in the early years of this century. The terrace of cottages on the left dates from about 1900. The land on the right, where the entrance to Waitrose's car park now stands, was occupied in the seventeenth century by the George public house, which was owned by Thomas Odel. He kept pigs on the nearby fields, and was so successful that, about 1680, he closed the pub and founded a hog market in East Finchley.

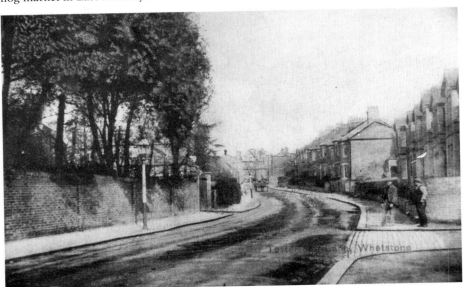

Totteridge Lane, looking east from about where Naylor Road joins. The long wall of the Whetstone House estate is on the left. This was to become Station Parade about 1935.

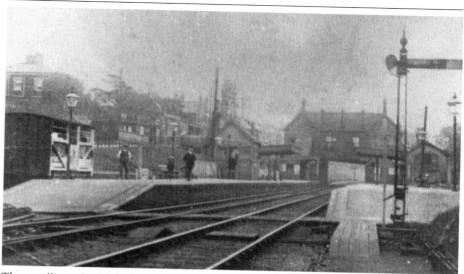

The small goods siding leading to the coal yard at Totteridge and Whetstone railway station, *c.* 1905. The station was opened in 1872 as part of the extension to Barnet. The coal yard has been replaced by the station car park, just as coal fires have been replaced by more modern forms of heating. The Great Northern Railway had stables and a horse hospital here, which until recently was used for light industry.

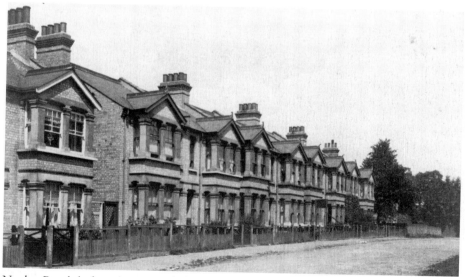

Naylor Road, before the west side had been developed, *c.* 1908. Houses like these were built on the former Woodside estate to serve office staff working in the City and using the nearby railway station. The houses were built to a high standard as the stone dressings show. A special footpath was constructed across the estate to facilitate pedestrian access from Friern Barnet Lane.

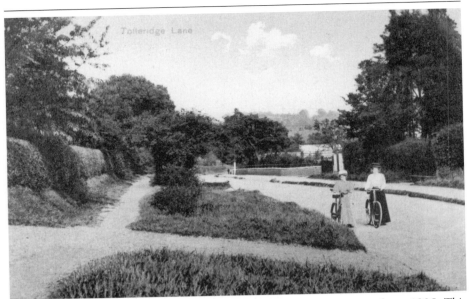

Totteridge Lane, looking east from about where Pine Grove now stands, *c.* 1905. This was formerly part of the Poynters Grove estate. Was the hill too steep for the ladies to cycle up, or were they just posing for the photographer?

Totteridge Lane, looking east, *c.* 1890. The front wall of the Puget chapel can be seen at the bottom of the hill on the right. In 1919 George Sherwood rented the site from the trustees to use for an engineering business.

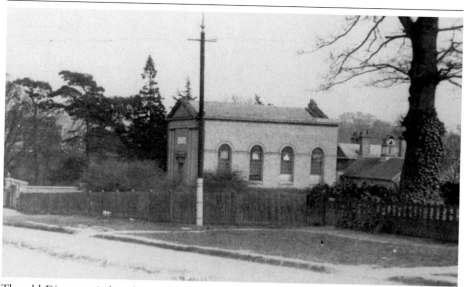

The old Dissenters' chapel in Totteridge Lane had a day school at the rear and was built with money from Catherine Puget in 1828. For many years, worshippers from Whetstone were carried across Dollis Brook in a wheelbarrow for a halfpenny until a brick foot-bridge was built by the Pugets in 1843. The chapel went out of religious use about 1882. It was used as a garage between the wars and as a Civil Defence Centre, complete with red-painted mortuary, in 1939. The site was redeveloped for housing in 1993.

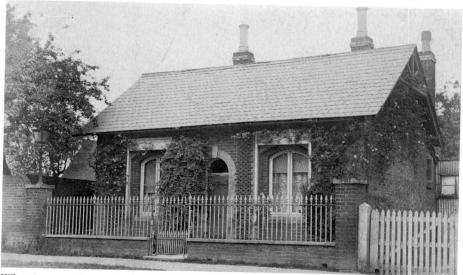

What is now Chapel Cottage in Totteridge village was built by the Puget family in 1840 as a mission to the poor of the district. The first minister was William Golding, described as a rural missionary. The chapel has been enlarged and is now a private house.

Laurel Farm at the end of Totteridge Green, *c.* 1920. The house is mentioned in the 1841 census. The principal crop was grass, and it was used as a dairy farm by the Morley family from 1897 to 1933. The fields used to cover what is now the Northiam estate and Woodridge School.

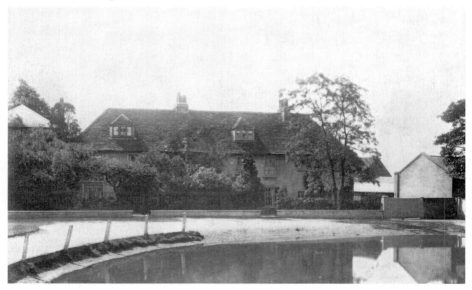

Home Farm on Totteridge Green in 1912. Parts of the house are said to be four hundred years old. It was damaged in 1944 by a flying bomb, which fell in the grounds of what is now Woodridge School. The fields belonging to this farm ran west towards Folly Brook.

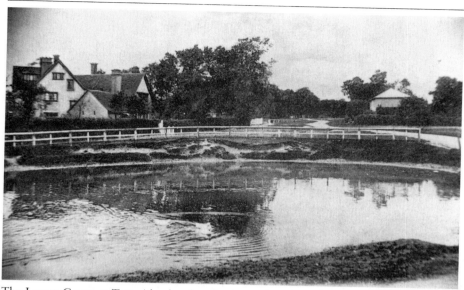

The Lower Green at Totteridge has hardly changed in the last 150 years, and no doubt during that time local children have fed the ducks as they do today. The unspoiled nature of present-day Totteridge is a tribute to the work of the local preservation society.

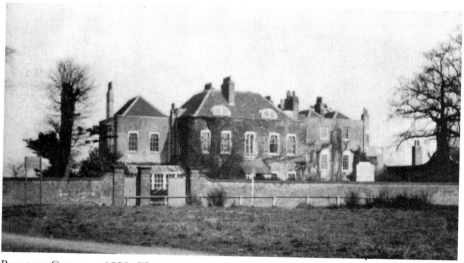

Poynters Grove, *c.* 1928. This was the home of the Puget family for about a hundred years. They were all public benefactors, largely unknown today, but whose memory should be revered. From 1896 to 1925 the house was lived in by Mrs Geraldine Harmsworth, mother of Lord Northcliffe, who at various times owned the *Daily Mail*, *The Times* and the *Daily Mirror*. The estate, once laid out by Capability Brown, was broken up in the 1950s.

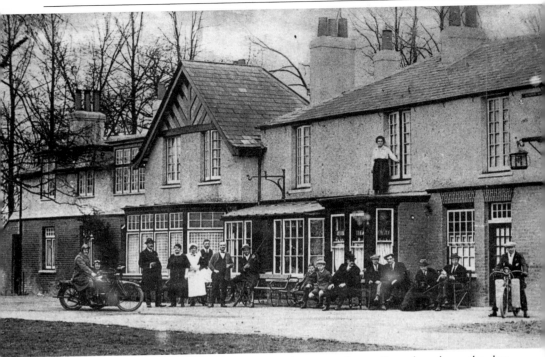

The Orange Tree, *c*. 1910. This was a popular venue for cyclists, though on the day this picture was taken they have been joined by motor cyclists complete with a side-car. One lady is so keen to be in the picture that she has climbed onto the roof. The building is remarkably unchanged today. There have been geese on the nearby pond for over a hundred years.

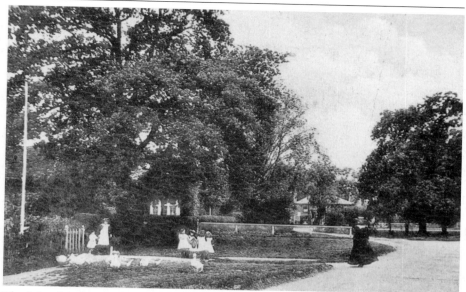

The School and Orange Tree, *c.* 1905. All the girls are wearing hats and pinafores. The flagpole at the front of the school reminds us of the traditions of Empire Day and Commonwealth Day, when the children would process round the playground wearing their brownies', guides', scouts' and cubs' uniforms.

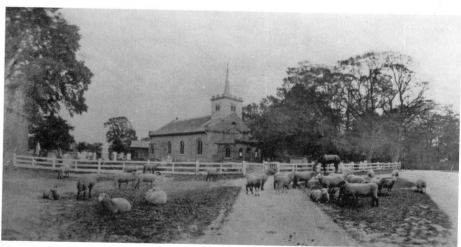

The rural setting of St Andrew's church, Totteridge, *c.* 1905. Although the sheep were probably posed for the occasion, they add much to the charm of the photograph. The yew tree in the churchyard is said to be 750 years old.

The vicarage in Totteridge is modestly hidden behind the church. This is a pity, because it is the first work (1892) of Sir Charles Nicholson, later to become famous as the architect of Truro Cathedral. His family lived at the Grange, a large mansion a little to the west of the church.

The Priory stands on the corner of Barnet Lane and Totteridge Lane. At one time, Totteridge church was under the Bishop of Ely, and it is said that the Priory was used by the Bishop's staff when visiting. Though extensively altered, it appears that three Jacobean cottages have been combined in one more modern house.

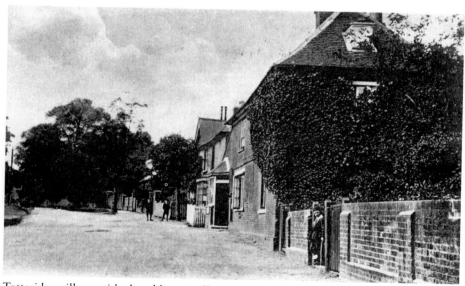

Totteridge village with the old post office, *c.* 1905. The post office was also a general store and was the nearest thing Totteridge had to a village centre. It was therefore an important meeting-place where news and views could be exchanged.

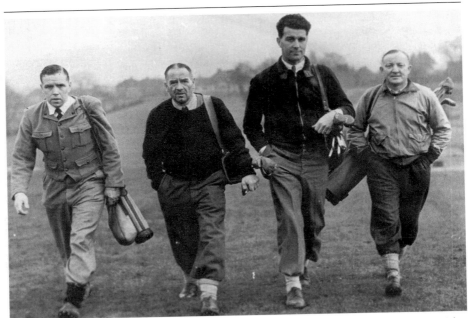

Arsenal Football Club has a long association with South Herts Golf Club in Totteridge Lane. Four of the great names in football can be seen here, *c.* 1937. Left to right: Laurie Scott, Alex James, Leslie Compton and Frank Moss. All were internationals.

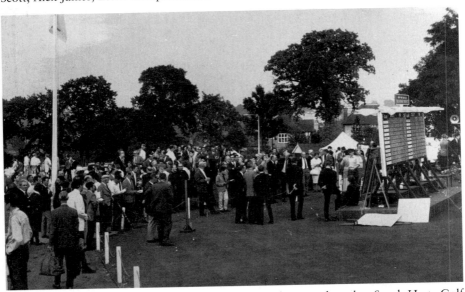

A large crowd studies the progress of the teams on the score-board at South Herts Golf Club. The event was the match for the Hudson Trophy competed for every year by golf clubs from all over the UK.

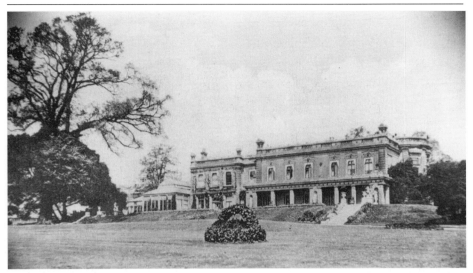

The name Copped Hall is thought to be a corruption of Copt Hall; copt means 'with a pointed or pitched roof' and may refer to an earlier building on the same site with a thatched roof. The building was extensively altered in the style of an Italian palace by Bulwer Lytton, who lived there in the 1860s.

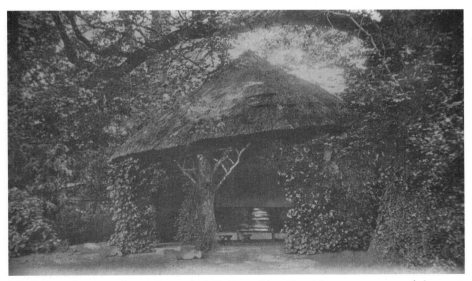

The Bulwer Lytton arbour, Copped Hall, Totteridge. Lord Lytton was one of the most prolific and popular of Victorian novelists. He was also very active in matters of social concern. He is said to have done much of his writing in this arbour. The local legend that he wrote *The Last of the Barons*, with its description of the Battle of Barnet, in this arbour is not true because the book was published before he moved to Totteridge.

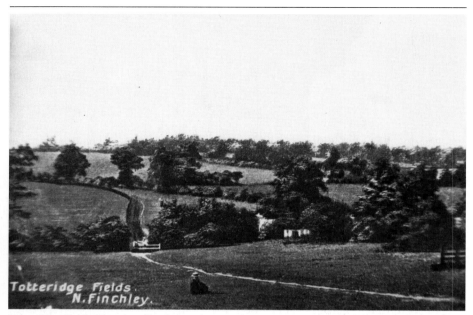

Totteridge fields have hardly changed since they were laid out about two hundred years ago.

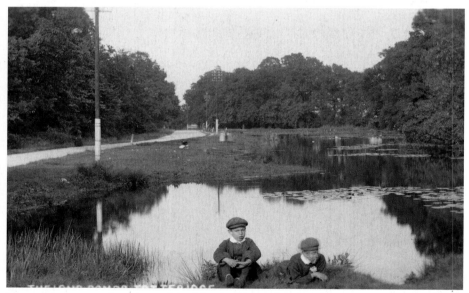

How many generations have fished in the Totteridge Ponds, in competition with the local herons? The ponds are probably the remains of clay or gravel pits. Gravel was used to mend the road surface until the introduction of tar and bitumen about 1910. Each pond has its own name.

# SECTION FOUR

# Around Friern Barnet and New Southgate

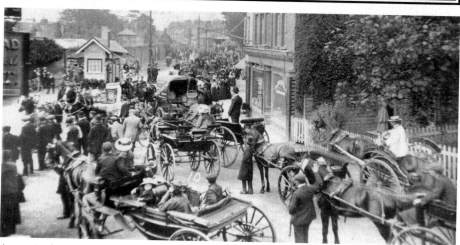

A carnival procession in Friern Barnet Lane. The occasion is believed to be that of the coronation of George V on 22 June 1911. The shops on the right still stand as does the Three Horse Shoes pub on the left.

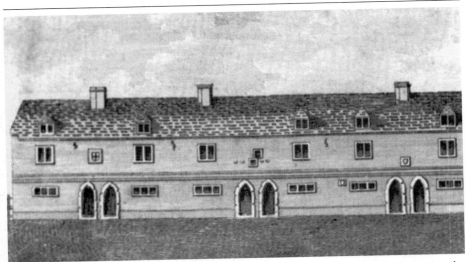

The Lawrence Campe Almshouses have the date 1612 incorporated in a stone on the wall. There were six almshouses for 'the free harbour and dwelling of twelve persons, or more, for ever'. The inmates, as they were called, were summoned to prayer by a red-painted bell hanging outside the middle almshouse. In 1612 the heirs of Lawrence Campe were allowed £1 6s 8d a year for the upkeep of the buildings.

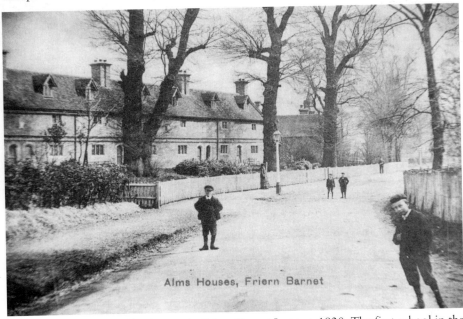

Alms Houses, Friern Barnet

The Lawrence Campe Almshouses in Friern Barnet Lane, c. 1920. The first school in the district, for ten poor boys and nine poor girls, was opened here in 1809. Pupils from St James' School, just beyond the almshouses, pose for the photographer.

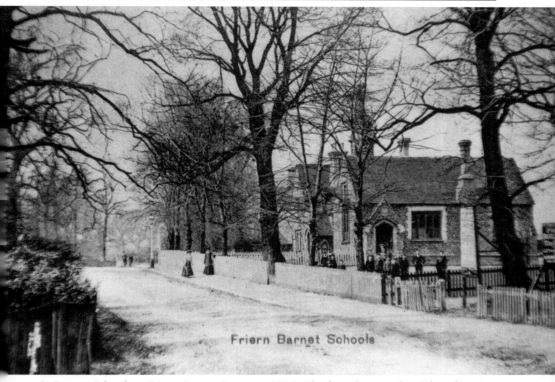

Friern Barnet Schools

St James' School in Friern Barnet Lane, *c.* 1906. The hoarding to the right advertises building plots in nearby Myddleton Park, which was steadily developed after 1904. In 1910 the headmaster reported that he was worried by the amount of traffic passing along the road outside the school and the danger to the boys. What would he have said today?

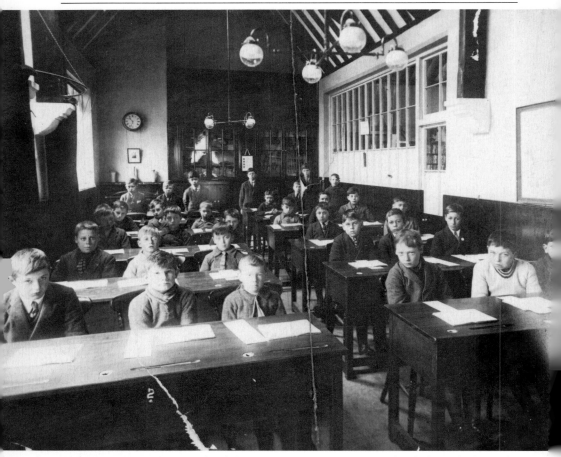

A classroom in St James' School, Friern Barnet Lane, *c.* 1925. The desks with their ink-wells, and the gas lights are typical of the period. Lenny Osborne is in the front row, second left, and Leonard Reboul in the second row, extreme left.

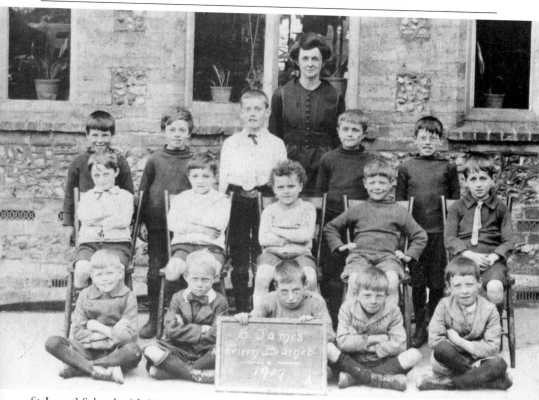

St James' School with Mrs Yeaxlee, wife of the headmaster, in 1919. The Yeaxlees lived in the schoolhouse next door. At that time, the public lending library was a large cupboard in the schoolroom, which Mr Yeaxlee opened on Tuesday evenings.

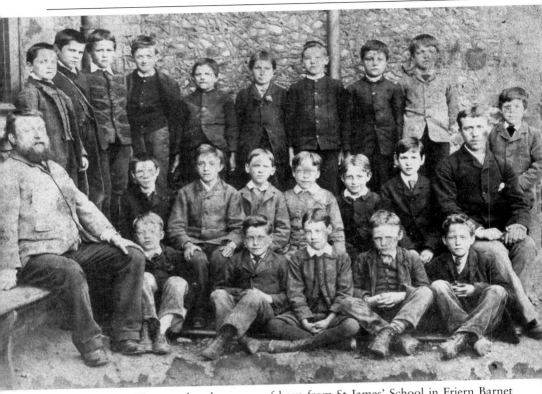

Mr Pitson, Mr Townsend and a group of boys from St James' School in Friern Barnet Lane, *c.* 1890. Mr Pitson (on the left) was dismissed in 1896 for drunkenness and incompetence. His successor, W.G. Collier, wrote 'The boys are extremely unruly. Stone throwing in the classroom is common. Few can read or write in a satisfactory manner.' All the boys are wearing boots. They would have left school at 12 or 13 for poorly paid and scarce local employment.

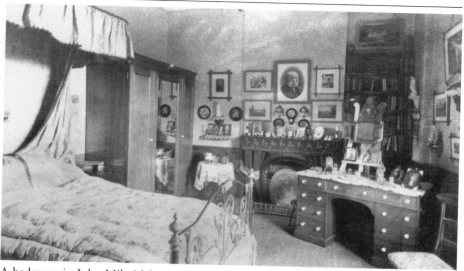

A bedroom in John Miles' Manor House, furnished in the height of Victorian taste. His own portrait hangs on the wall above the mantelpiece. The Manor House is now the clubhouse of the North Middlesex Golf Club, and was built by John Miles in 1851 on the site of Friern Manor Farm. (See also p. 104.) The land which John Miles purchased for £6,000 included the site on which the golf club is now situated and all the land between Oakleigh Road and Friern Barnet Lane.

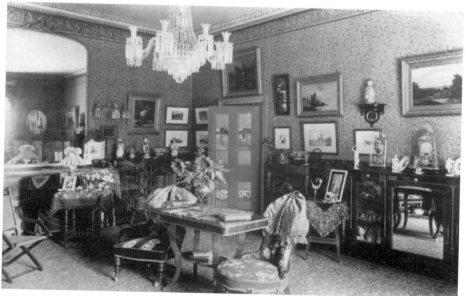

The 'Withdrawing Room' of Manor House. The Victorians' love of elaborate decoration is well illustrated and, although not always to modern taste, the furniture and particularly the chandelier indicate both wealth and awareness of fashion.

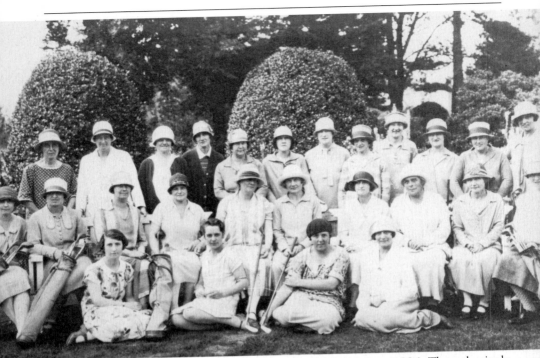

The lady members of the North Middlesex Golf Club, 29 June 1926. The only single ladies in the group are the Misses Lincoln, J. Dare and Miss Dare, who are sitting on the grass. All the rest are married ladies.

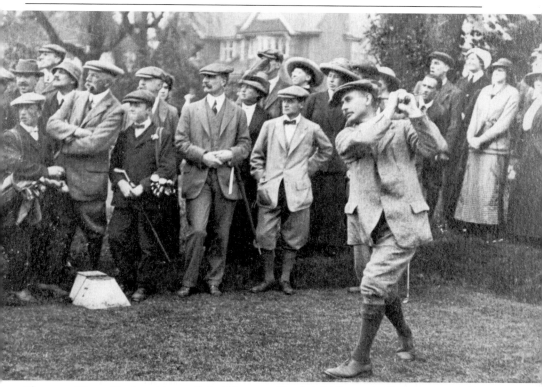

The great Harry Vardon drives off the 7th tee at North Middlesex Golf Club, though he was the professional at South Herts Club in Totteridge Lane, in the 1920s. He lived in a modest house, No. 14 Totteridge Lane. He was British Open Golf Champion a record six times.

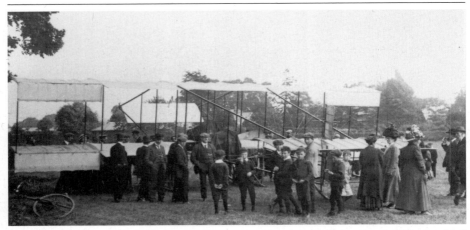

A most unusual event for a golf course! In 1913 a Bristol box-kite landed on the third fairway, though it is doubtful whether the members allowed it to interfere with play. The wings were unbolted and the machine was loaded onto a lorry and taken back to Hendon aerodrome.

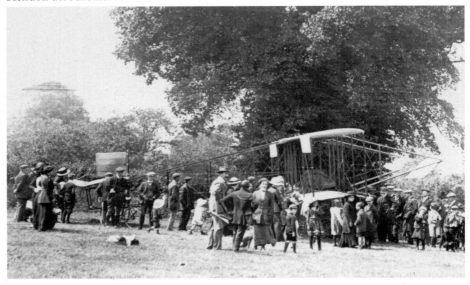

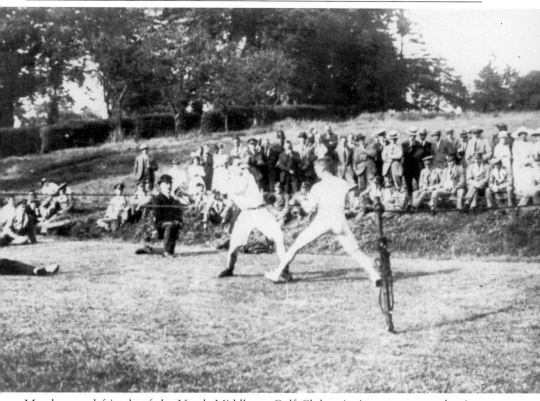

Members and friends of the North Middlesex Golf Club enjoying an amateur boxing tournament on the eleventh fairway sometime during the First World War. Presumably the boxers enjoyed it as well! Many of the spectators are wearing the uniform of wounded soldiers, the so-called 'Hospital Blues'.

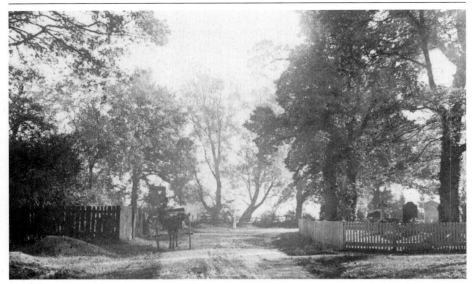

Friern Barnet Lane, *c.* 1885. This photograph was taken by a member of the Lyonsdown Photographic Society. It shows the pound on the left and the fence of St James' churchyard on the right. At that time the road surface had not been made up. The cart is driving on the wrong side of the road.

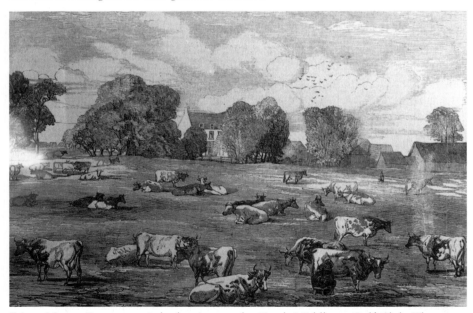

Friern Manor Farm occupied what is now the North Middlesex Golf Club. The estate was bought by John Miles in 1851, when he rebuilt the house. He also renamed it the Manor House, thus leaving a legacy of confusion to future historians.

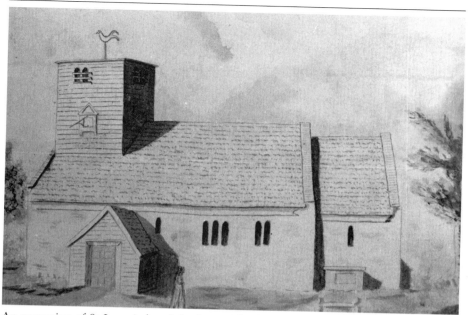

An engraving of St James' church in the parish of Friern Barnet, dated *c.* 1780. There is evidence that the parish may have been in existence before the Norman Conquest, and there is Norman work over the doorway in the porch.

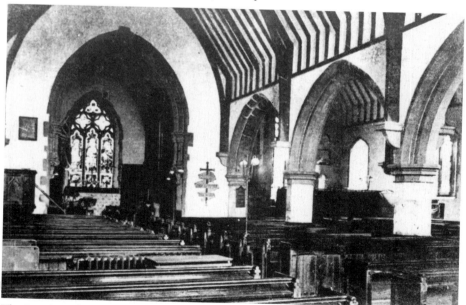

The interior of the parish church of St James, Friern Barnet, *c.* 1930. There has been a church on this site since before records begin.

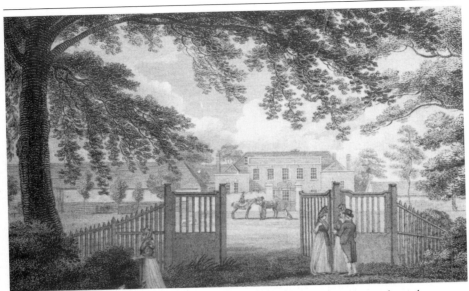

Friern Barnet did not have a proper manor-house. The building shown here, known as Friary House, was occupied by John Bacon about 1780. The grounds are now Friary Park, and the pathway leading from the parish church has retained its original shape. When this house was rebuilt in 1871, the cellars gave rise to the usual legend of underground passages leading to the parish church.

This house in Friary Park was built for E.W. Richardson in 1871, and bought by the local council in 1910. Even before that date, there was a tradition of using the land for community purposes. For example, the Diamond Jubilee of Queen Victoria was celebrated by a children's party held in Mr Richardson's grounds.

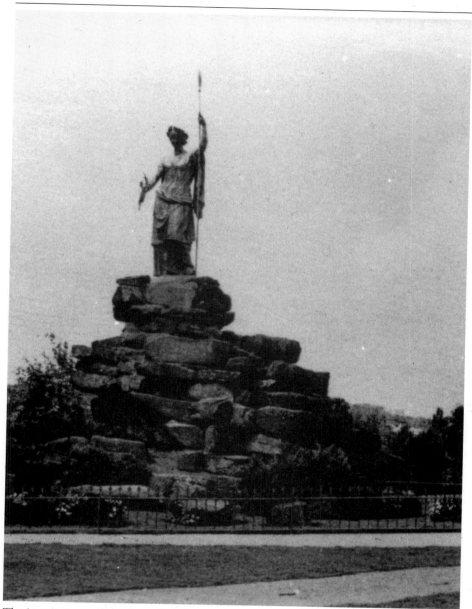

The inscription on this statue in Friary Park reads 'In memory of the Peace Maker King Edward VII. Erected by Sydney Simmons J.P. the donor of this park which was opened to the public on May 7, 1910 the day following His Majesty's lamented death'. Is there any child in the district who has not climbed it? Mr Simmons is remembered in Simmons Way on the Russell Lane estate.

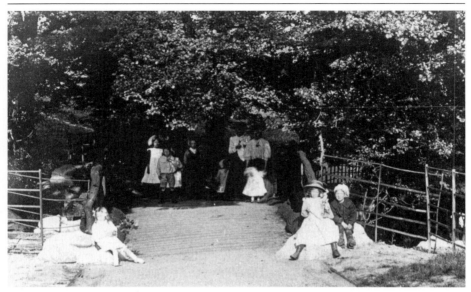

The bridge in Friary Park, *c.* 1912. The bridge crosses Blacketts Brook, which rises on the North Middlesex Golf Course and flows into a culvert under Friern Barnet Lane and eventually into Pymmes Brook. All the girls are wearing straw boaters and pinafores, so called because they were 'pinned afore'.

Friern Barnet Mink Farm in 1957. We have not been able to find out exactly where this was. It is an interesting and early attempt at diversification. Could it be called a 'cottage industry'?

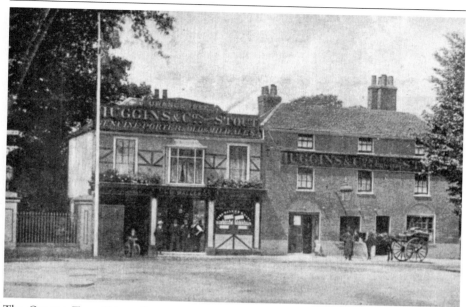

The Orange Tree, Friern Barnet, c. 1900, was once called the Crown and gained its present name about 1675 when it was a popular haunt of Nell Gwyn, who used to sell oranges before she was noticed by King Charles II. This picture shows the old building, which was remodelled in 1909.

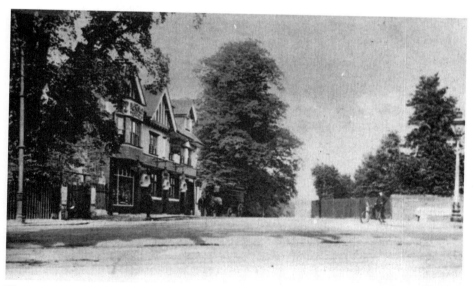

The Orange Tree, c. 1915. The Drinking Fountain and Cattle Trough Association provided facilities like that shown opposite the pub at crossroads throughout the London area.

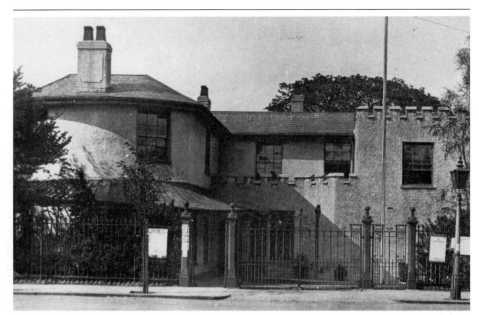

The Priory stood on the corner of Friern Barnet Lane, opposite the Orange Tree. This 200-year-old building was taken over by Friern Barnet Council in 1906 and used as their offices until 1939, when it was pulled down to make room for today's Town Hall.

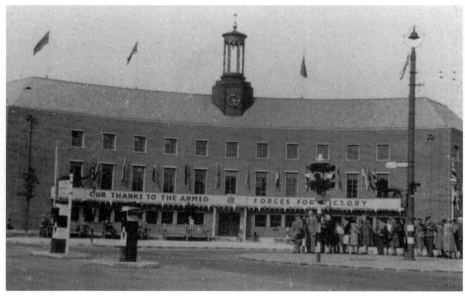

Friern Barnet Town Hall in 1945. The time is 5.15 p.m. and a group of council office workers is waiting to take the bus home. The spacious forecourt has been destroyed to make room for office workers' cars.

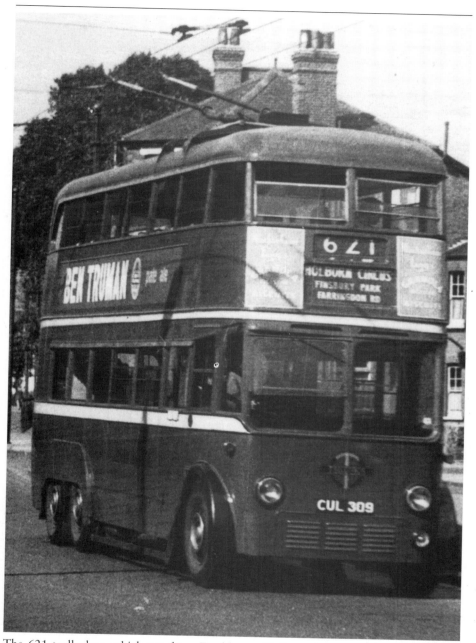

The 621 trolleybus, which ran from Finchley to Holborn, in Friern Barnet Road near the corner of Ramsden Road. The fierce acceleration of the trolleybuses made some people sick. The first 521 and 621 trolleybuses ran in March 1936, and they were replaced by Routemaster buses in November 1961.

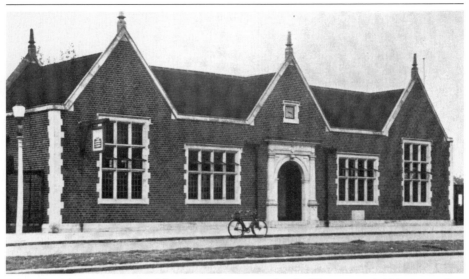

Friern Barnet Library, 1934. The foundation stone for the library was laid in September 1933, and the library was actually opened the following year. Before that time, the lending libraries had been housed in cupboards in local schools or had been commercial libraries like Boots' Twopenny Library.

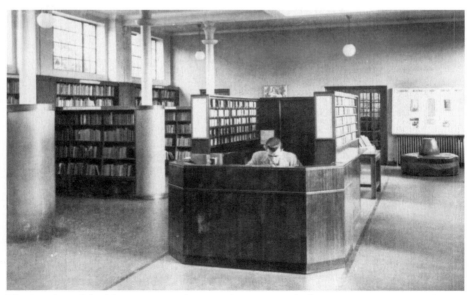

The interior of the library, 1934, showing the 1930s style furniture in pristine condition. Since its opening, the library has been used for many evening meetings, particularly by the WEA and the Gramophone Society.

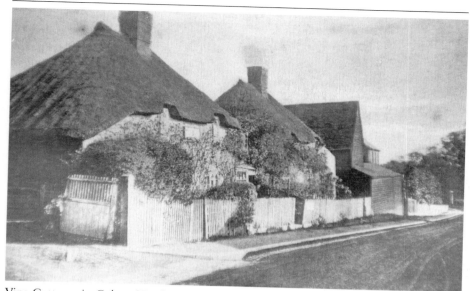

Vine Cottages in Colney Hatch Lane near the Town Hall, c. 1900. Mr Paul, one of the pioneers of film making and a specialist in exciting fire scenes, used the nearby Orange Tree as his headquarters. In 1909 these cottages were accidentally burned down.

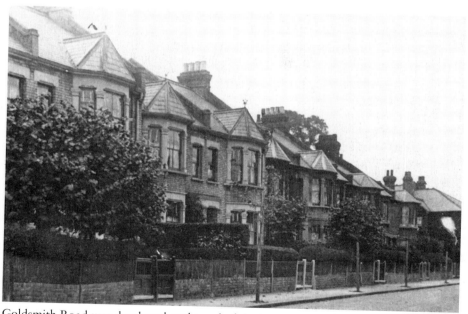

Goldsmith Road was developed at the end of the last century. The nearby Colney Hatch Asylum provided over a thousand jobs. Round their windows, these late Victorian villas have the stone decoration so typical of the period.

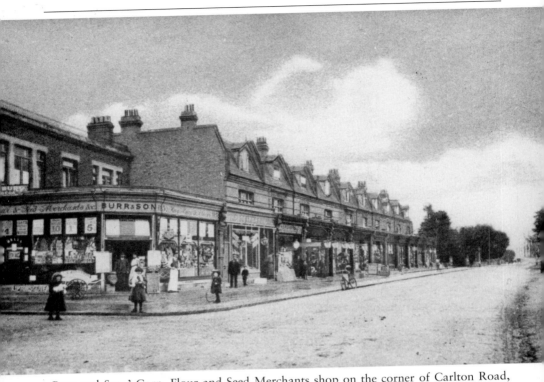

Burr and Sons' Corn, Flour and Seed Merchants shop on the corner of Carlton Road, *c.* 1905. The shop was built on the playground of the former Friern Barnet Girls' School. The trams have not arrived yet. Harries's double-fronted draper's shop has glass gas globes to illuminate both the window display and the pavement.

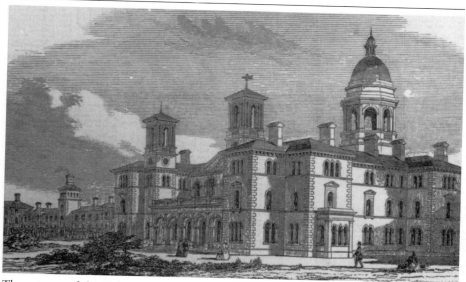

The patrons of the Colney Hatch Asylum for the Lunatic Poor included Prince Albert. It was built between 1849 and 1851 at a cost of £400,000 on a healthy and well-drained site in open country. The asylum had its own railway station and burial ground. The admissions register for 1851 includes among the reasons for Lunacy, 'Socialism' and 'Extreme Arrogance'. At that time, there were about two thousand five hundred patients and over a thousand staff.

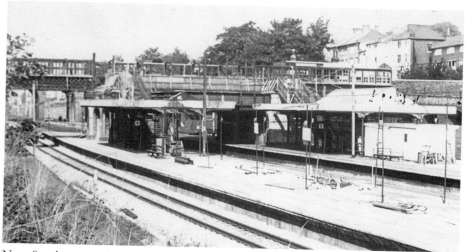

New Southgate station was originally called Colney Hatch. The association with the asylum was felt to be detrimental and the name was changed. The newly-named station was enlarged in 1890. The new housing estate nearby also had its name changed to New Southgate.

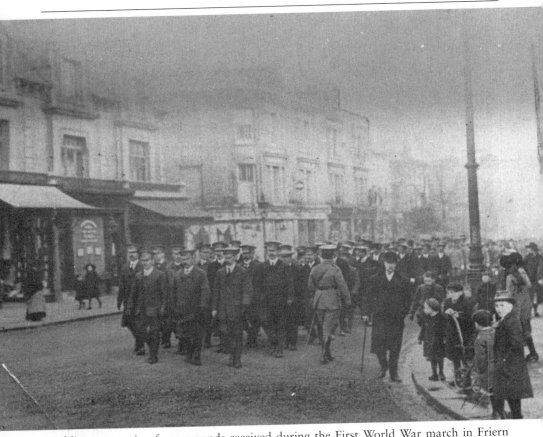

Soldiers recovering from wounds received during the First World War march in Friern Barnet Road as part of their road back to fitness and the Western Front. So many soldiers were wounded in the war that Colney Hatch had a large recuperation department.

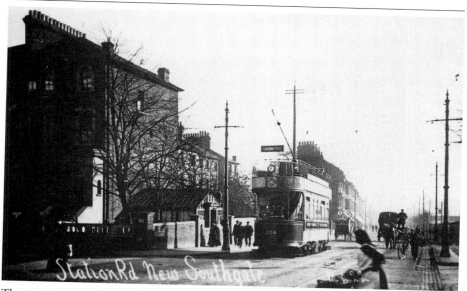

The trams came through Station Road, New Southgate on 8 April 1909. This one is bound for Finchley probably from Finsbury Park. The lady with the pram looks anxiously lest the cyclist or horse and cart coming up the hill should harm her baby.

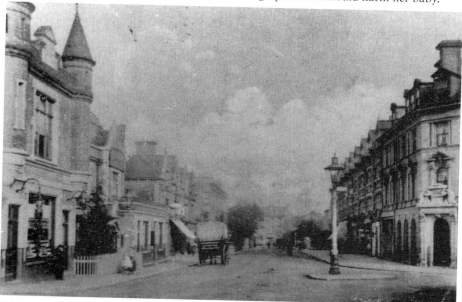

Friern Barnet Road by the junction with Station Road. No tram lines are apparent, so the picture must date from about 1905. What is now the Turrets on the left was originally the Railway Arms. The bank on the opposite corner has been converted into another pub, called the Banker's Draught.

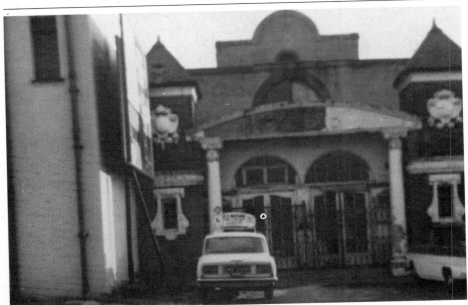

The Coronation Cinema in the High Road, *c.* 1960, was named in honour of King George V. It was originally the New Southgate Assembly Rooms and had a stage and dressing-rooms at the rear. The building on the left was a powder puff factory. Shortly after this photograph was taken most of the district was redeveloped.

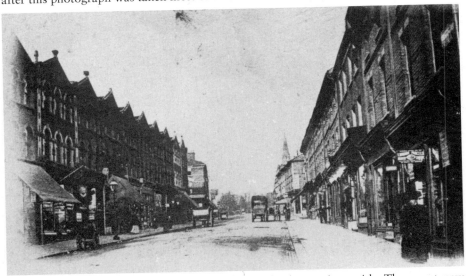

New Southgate High Road, *c.* 1905, was probably then at its zenith. The smart new shops could never attract enough custom from such a small catchment area. Even the police station seen on the left is now no longer active. In 1890 the road was called Bestyle Road after the nearby road junction.

Holly Park School scholarship boys, 1919. The headmaster, W.G. Collier, sits on the left. He had been invited to open the school in 1906. He had two ideas that were unusual for the time. The first was that if children are interested in their lessons, they will be better behaved. The second was that if children understand things, they will be more likely to remember them.

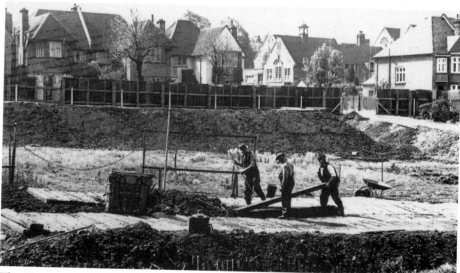

The Crescent, Friern Barnet, c. 1930. Holly Park School can be seen at the back on the right. The land was used for controlled tipping before being covered with top soil and let out as allotments from 1926 onwards.

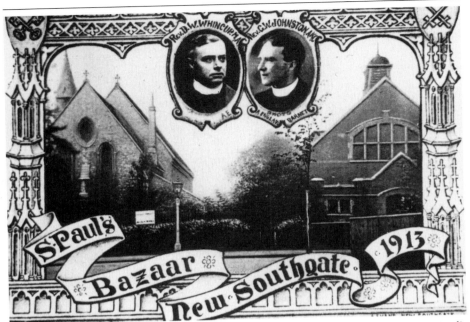

The earliest St Paul's church used a building in Ely Place in 1860. The present St Paul's church, shown here, was erected in Edmonton Parish in 1873. It was designed by Sir Gilbert Scott in the Early English style.

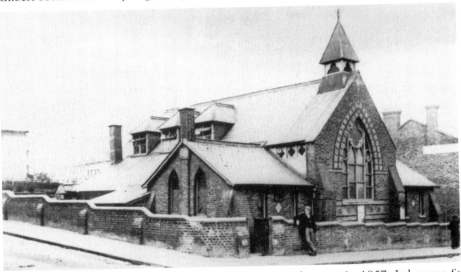

St Paul's School began life as an infant school in rented rooms in 1857. It became St Paul's National School in 1874, when it moved to the former church building in Ely Place. The present building dates from 1893 and is largely incorporated inside the additions of the 1970s.

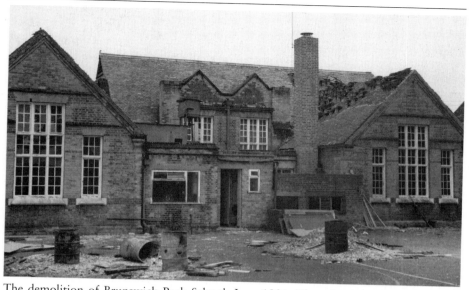

The demolition of Brunswick Park School, June 1991. The school was built as an 'all age' school to serve the local estate and was used for about a hundred years. A block of flats now stands on the site.

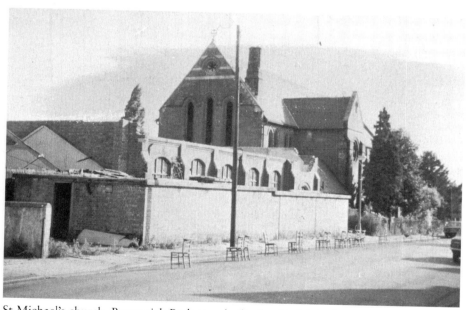

St Michael's church, Brunswick Park, was built of red brick in the Early English style in 1902 at a cost of £5,000. The church hall was added in 1913. The congregation dwindled over the years to such an extent that it was decided to demolish the church and use the land for a Church Housing Association project.

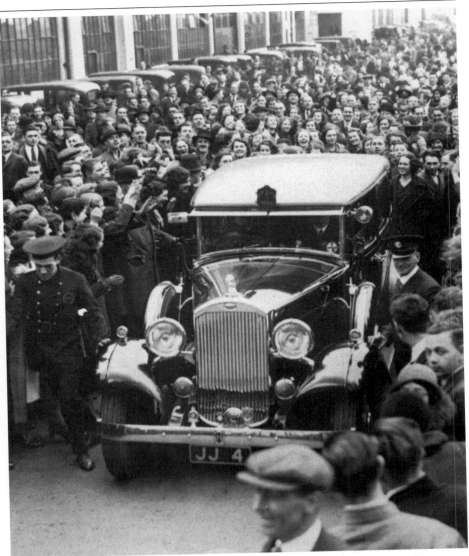

The Duke of York, later to become King George VI, visited the Standard factory on 8 February 1934. Here his official car is seen leaving the site with the works' fire brigade members helping to clear the way through enthusiastic crowds.

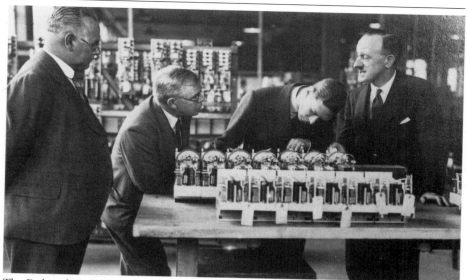

The Duke of York (third from left) examining radio valves at the Standard Telephone and Cables factory in 1934. The Standard were leading manufacturers of communications equipment. During the Second World War the firm employed over twelve thousand people, many of whom worked on secret equipment like Radar. On the night of 14 January 1923, the first ever transatlantic broadcast of speech was received in a small wooden hut on this site.

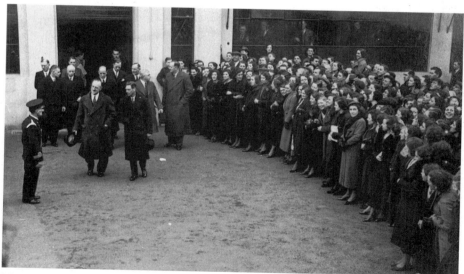

Mr McArthur, who had over thirty years of service and was head of the works' private fire brigade, waits to be presented to the Duke. The brigade's busiest time was on the morning of 23 August 1944, when a flying bomb landed, killing thirty-three and injuring over two hundred.

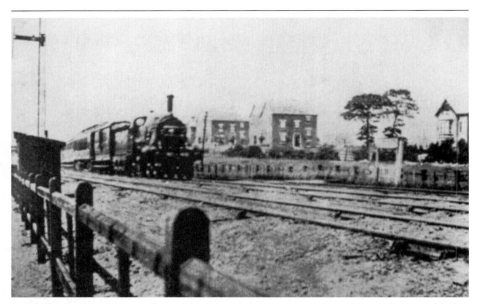

A 'Coffee Pot' engine speeds past Brunswick Park on its way to Kings Cross, probably about 1880. Although engines are now much more powerful, journey times are hardly shorter today than they were at that time.

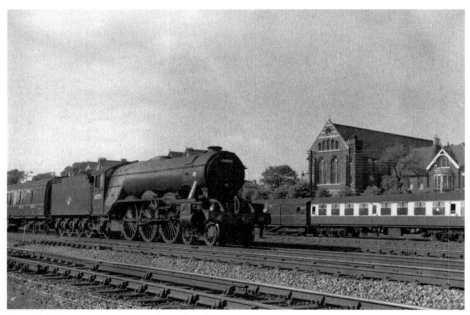

No. 60059 passing Brunswick Park, also on its way to Kings Cross, *c*. 1960. St Michael and All Angels' vicarage can be seen in the background.

# SECTION FIVE

# Around North Finchley

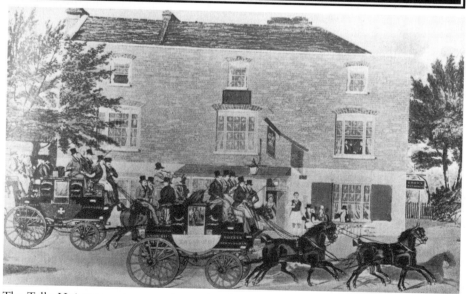

The Tally Ho! was a stage-coach running from London to Birmingham, *c.* 1825. It is seen here with the guard blowing his post-horn. The coach was owned by William Chaplin, whose stables were in North Finchley. The Tally Ho! stables gave their name to the road junction, Tally Ho! Corner, and eventually to the pub. One of the guards was Robert Lloyd, who became landlord of the Swan with Two Necks in Whetstone.

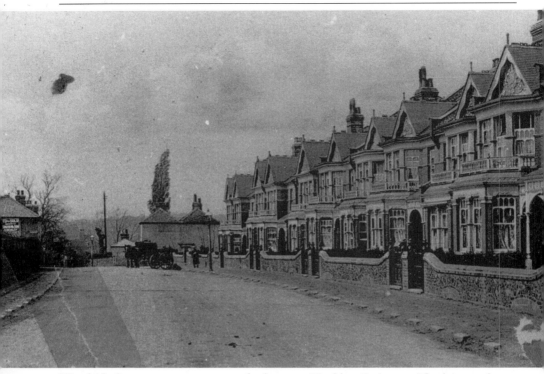

Woodside Lane runs across part of what was Finchley Common. The houses shown here date from 1904 just before this picture was taken. There is a coalman's cart near the foot of the hill. The name Woodside is a reminder that at one time the whole district was heavily wooded.

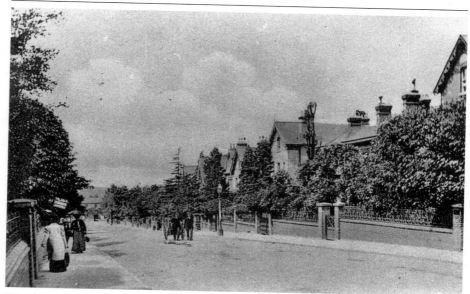

Woodside Park Road, *c.* 1912. The drop in land values in the 1880s, caused by the influx of cheap American grain, released what had been agricultural land for the building of high quality estates which were often called 'parks'. Woodside Park, Torrington Park and Oakleigh Park are examples.

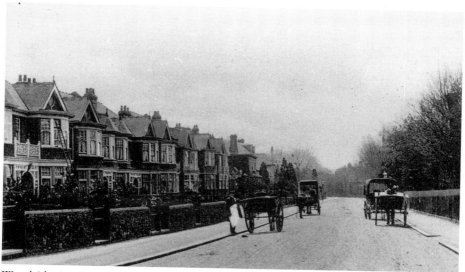

Woodside Avenue, *c.* 1910. These houses were for prosperous people and built to the best standards of taste and workmanship. They were near enough to Woodside Park station not to need carriage sweeps and so could be built more closely together. No less than four tradesmen's carts are making deliveries. What is the ladder for?

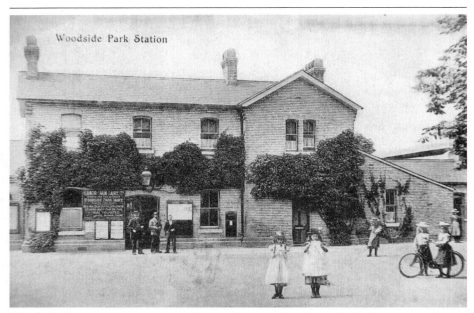

Woodside Park station, *c.* 1910, with an advert for the Woodside Park dairy which was part of the Manor Dairy combine. The station staff, together with a group of schoolgirls in their straw boaters, make this an exceptionally well-composed picture. Much of the station can still be recognized.

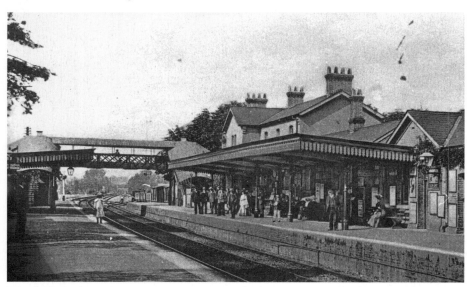

Woodside Park station, *c.* 1910. Ever since the line was opened it has been the subject of complaints about poor service; similar complaints about the Northern Line tube are still made today.

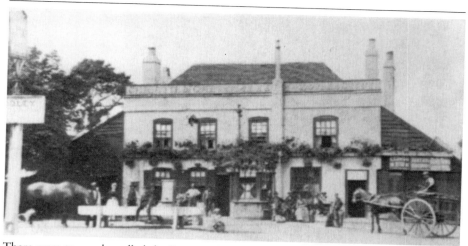

There were two pubs called the Swan with Two Necks on Finchley Common – one next to Swan Lane and another, half a mile further south, which is shown here *c.* 1880. This building was a coaching inn with classical Georgian four-by-three windows and with stables at the rear. It was rebuilt in the 1880s.

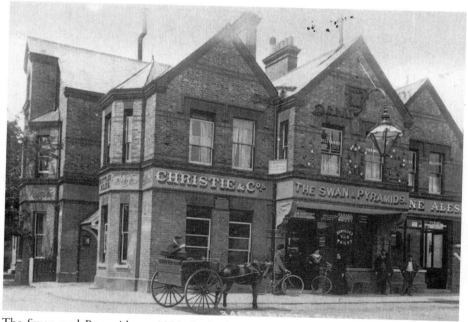

The Swan and Pyramids, *c.* 1920, is the less confusing name given to what was the Swan with Two Necks (see above). It boasted one of the largest gas globes in the vicinity. For many years the forecourt was used as a bus turning point. Since this picture was taken, the pub has been rebuilt for the third time.

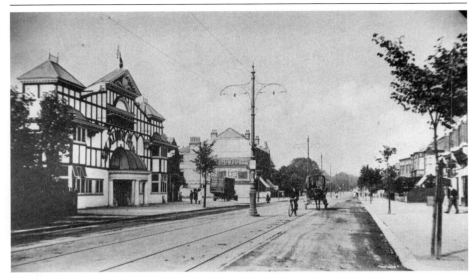

The Finchley roller-skating rink stood to the south of the Swan and Pyramids, *c.* 1915. It was opened in 1910 but soon became a cinema. It was not a success and was replaced by the lorry depot of Carrimore Six Wheelers in 1923. This in turn was replaced by the Metropolitan Police garage.

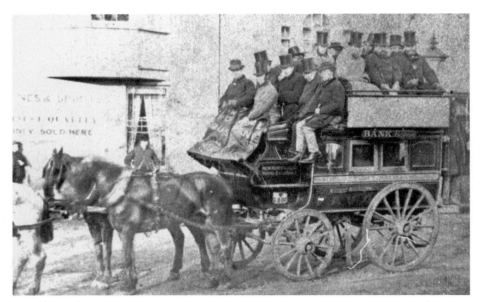

The horse bus to Bank outside the Torrington Arms, *c.* 1865. There are fourteen passengers on top. Ladies with their hooped skirts were not popular. It was said that only four of them would completely fill the downstairs compartment. The journey time of an hour and a quarter compares well with today's figures.

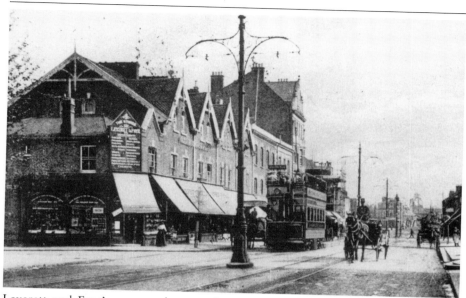

Leverett and Frye's grocers shop on the corner of Torrington Park, *c.* 1908. The unmarried staff 'lived in', occupying rooms above the shop. The housekeeper, Mrs Macdonald, was such a good cook that when she retired to open a guest-house in the west country, a number of Finchley residents used to go there regularly on holiday.

Torrington Park has been developed and redeveloped since 1872. A privet hedge was absolutely *de rigueur* at the turn of the century. The grass verge without a kerb stone and the absence of parked cars are reminders of a bygone age.

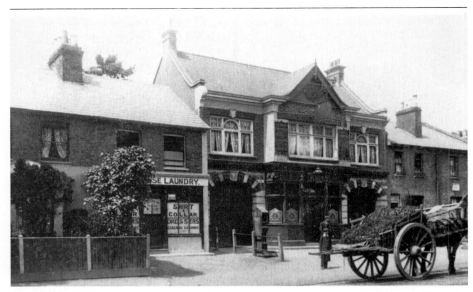

The Malt and Hops is another late Victorian beer house. Waterloo Cottages on the right were named by Mr J. Read, late of the 10th Royal Hussars, who, at the battle, had a musket ball pass through his moustache. The ball went on to kill his neighbour. Mr Read died on 4 March 1871.

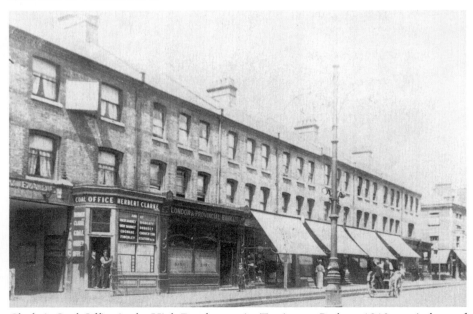

Clarke's Coal Office in the High Road opposite Torrington Park, *c.* 1910, reminds us of the importance of coal not just for heating but for cooking on the kitchen range as well. Access to the stables, which still exist, was through the archway on the left.

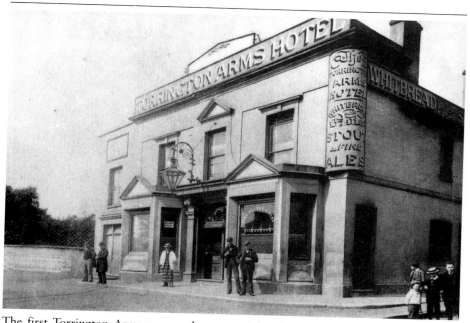

The first Torrington Arms was used as a receiving depot for the post office and as a departure point for horse buses. The building shown here was pulled down and rebuilt in 1900.

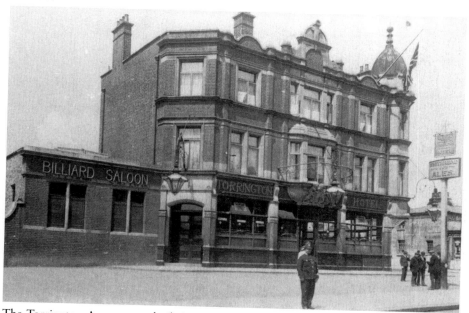

The Torrington Arms was rebuilt in 1900 with a prominent billiard saloon and rebuilt again in its present form about 1960.

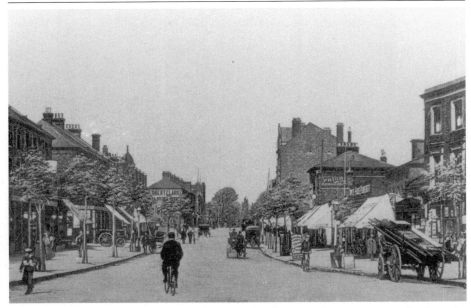

The view from Tally Ho! Corner, looking north. The trams have not yet arrived, so the picture probably dates from about 1900. The shop of Benjamin Prior, draper and milliner, can be seen on the right, as can a cart delivering furniture to Jelks'.

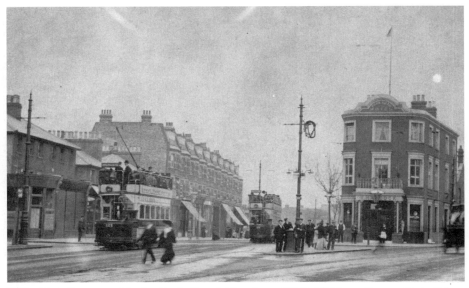

Tally Ho! Corner with the Park Road Hotel, *c.* 1915. William Barnard's builders business stood on the corner of Stanhope Road, where Woolworths now stands.

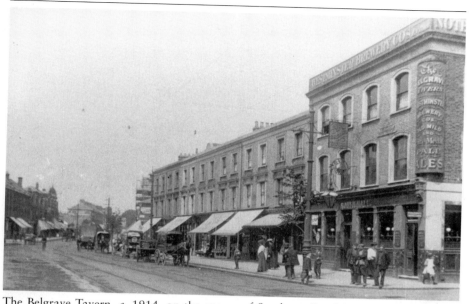

The Belgrave Tavern, *c.* 1914, on the corner of Stanhope Road is now Pages Bar. The importance of deliveries to houses is obvious from the number of small horse-drawn carts parked outside many shops.

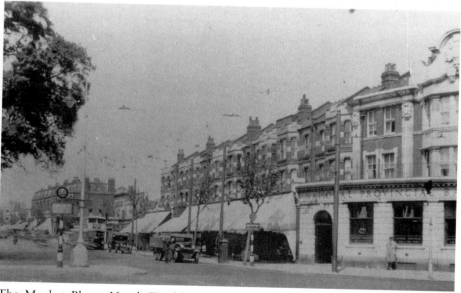

The Market Place, North Finchley, *c.* 1937. Trams have now been replaced by trolleybuses with their double overhead cables. Priors' new shop (later to be called Owen Owen) had not yet replaced the Stephens Memorial Hall on the corner of Castle Road. The old Grand Hall Cinema can be seen just by the bus-stop.

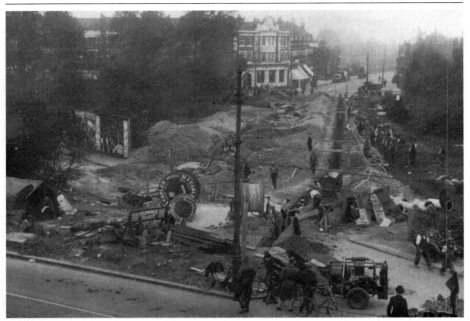

The Kingsway, North Finchley, was cut through what had been the grounds of Orchard Lodge in 1934. Workers employed by the contractors Fitzpatrick are laying electricity cables, helped by the usual knot of onlookers.

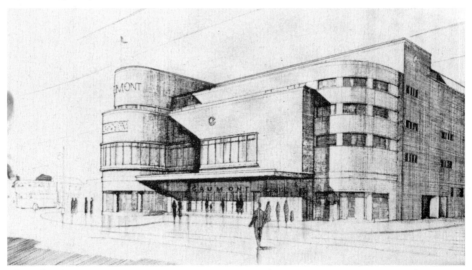

The island space created by the construction of The Kingsway was used for a new Gaumont Cinema, opened by the Mayor of Finchley in 1937. The rounded shop fronts are characteristic of mid-thirties' taste. There was a restaurant serving teas and refreshments on the upper floor.

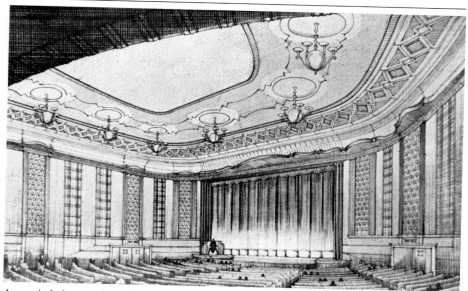

An artist's impression of the interior of the Gaumont from the rear of the stalls. The ceiling decorations are worthy of note, as is the organ which has been raised. An important part of early cinema programmes was community singing, with the words being indicated on the screen by a bouncing ball.

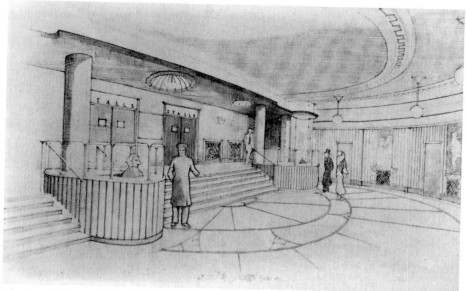

The lavish foyer of the Gaumont was intended to provide plenty of room for people to queue for admission in comfort. There were even queues for the Saturday morning 'Kiddies Klub', featuring characters such as Buck Rogers.

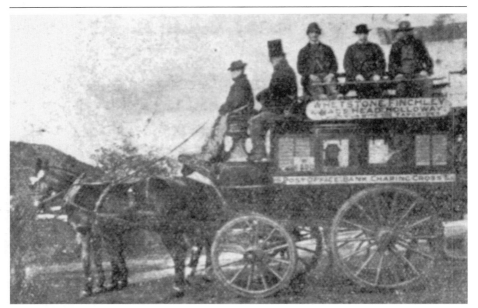

The Whetstone to London horse bus, shown in a picture said to date from 1853, but which is probably a little later. The proprietor was Peter Mountain, whose stables were in Whetstone High Road, just north of where Waitrose now stands.

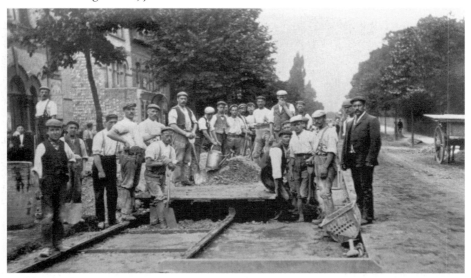

Laying tramlines at North Finchley, c. 1905. In the 1890s there were objections to the bringing of trams to Finchley because it was felt that the 'rough classes from London' would invade the district. It was not until 1904 that a tram depot was built in Woodberry Grove. The tramlines were opened in 1905. At that time everybody wore a hat. Workmen wore caps but the foreman (where is he?) would wear a bowler.

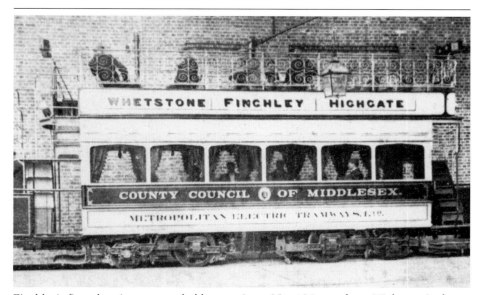

Finchley's first electric tram, probably type A car No. 125, ran from Highgate Archway to Whetstone on 7 June 1905. The extension to the top of Barnet Hill was not built until 16 March 1907. The crews of the trams at that period were required to work straight through their shifts with no break for refreshment nor calls of nature. The open front of the tram left the driver completely exposed to the weather.

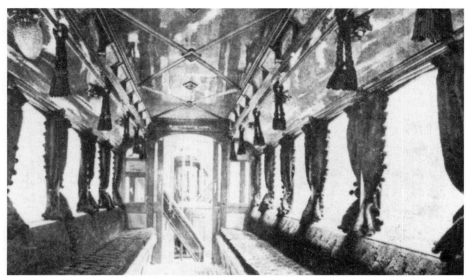

Finchley's first tram was specially prepared for the occasion with curtains and inward facing seats. Tram fares were low and this opened up the possibility of cheap travel to places of employment for many poor people of the district. Cheap, reliable public transport was one of the achievements of the Edwardian age.

The old Postman's Office in Ballards Lane, *c.* 1910. Ballards Lane, at one time called Barrow Lane, probably gets its name from the Ballard family, who owned land in Finchley as early as 1300.

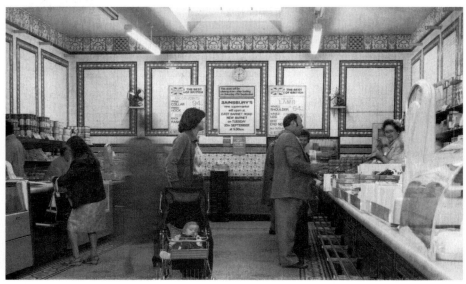

J. Sainsbury had a chain of shops all round the district at Whetstone, North Finchley and East Barnet. They all had a decorative, tiled floor. The marble-topped counters were hygienic and cool. The staff would shape your packet of butter into a cylinder using wooden butter pats, which they dipped in water.

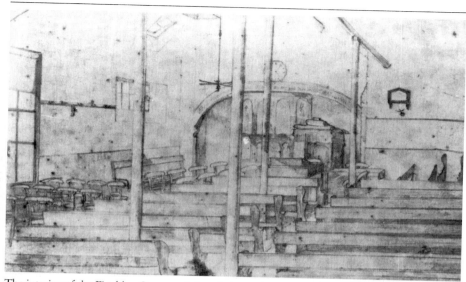

The interior of the Finchley Cottagers' chapel, drawn by Miss M.R. Ridley in 1879. The chapel was built by Mr T.C. Newman in the grounds of Orchard Lodge as an attempt to combat drunkenness and brawling in the Lodge Lane district. Orchard Lodge was destroyed in the 1930s when The Kingsway was cut through to join Woodhouse Road to Ballards Lane.

The Baptist Schoolroom in Dale Grove, drawn in 1955. This chapel was built about 1864 and was originally used by the Congregationalists as a day and Sunday School as well as for worship. The funds and land were largely provided by the Puget family. It consisted of two rooms, one for forty infants and the other for forty older pupils. It was sold to the Baptists in 1893.

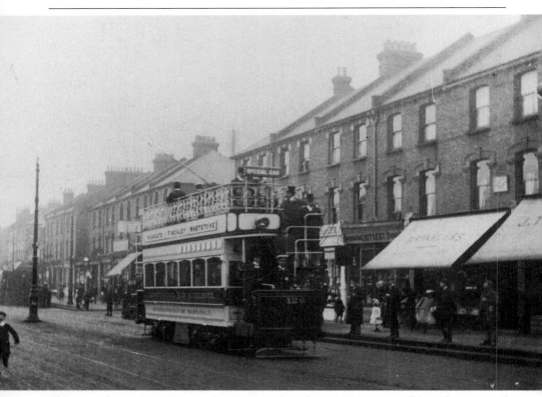

This special tram No. 126, passing Regent's Parade, *c.* 1905, may well have been one of the first trams to Barnet. It is certainly attracting the attention of the passers-by. The gentleman at the front is important enough to wear a top hat.

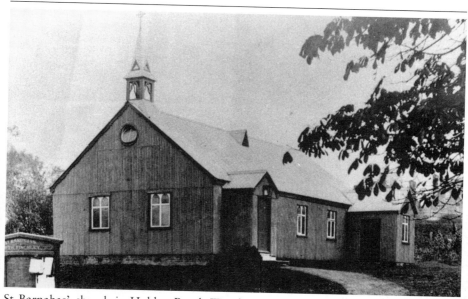

St Barnabas' church in Holden Road, Woodside Park, originally used this corrugated iron building constructed in 1885. By 1903 the congregation numbered ninety-eight and a new church was built. The iron hut was then moved to Gainsborough Road where it served as the parish hall. Holden Road is named after the estate developer.

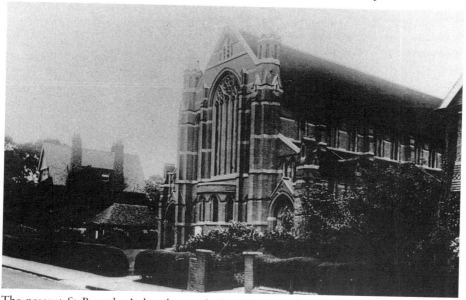

The present St Barnabas' church was designed in 1912 by J.S. Alder. It is of red brick with stone dressings and has a stone interior with a wooden barrelled roof. All this gives the church a splendidly warm acoustic quality.

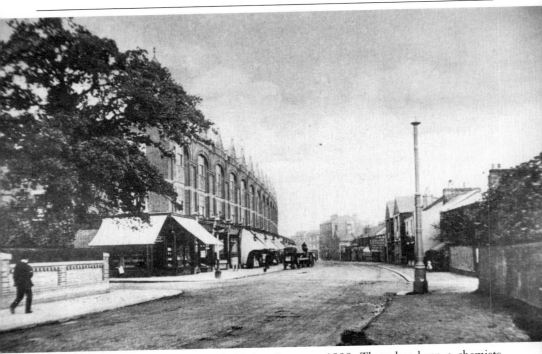

Ballards Lane at the junction with Nether Street, *c.* 1900. There has been a chemists shop on this corner since this picture was taken. Jelks and Sons' furniture warehouse can be seen on the right. The Jelks were a prominent local family who lived in Whetstone.

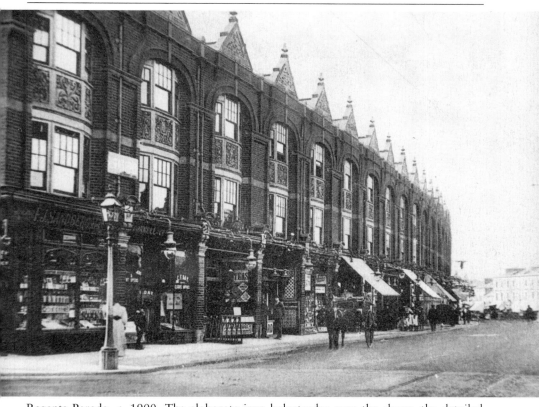

Regents Parade, *c.* 1900. The elaborate iron balustrades over the shops, the detailed pargeting and gables, and the large gas globes set a standard of Edwardian luxury befitting what was Finchley's most up-to-date shopping centre.

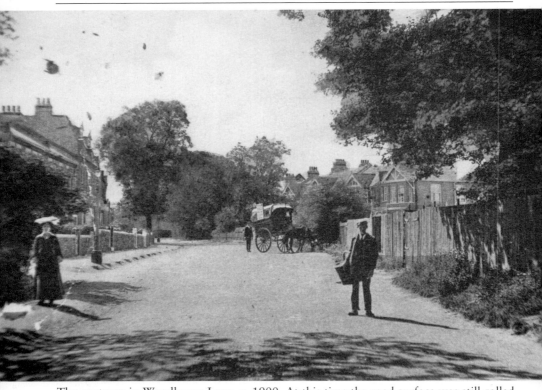

The postman in Woodhouse Lane, *c*. 1900. At this time the road surface was still rolled gravel. The road has since been called Woodhouse Road.

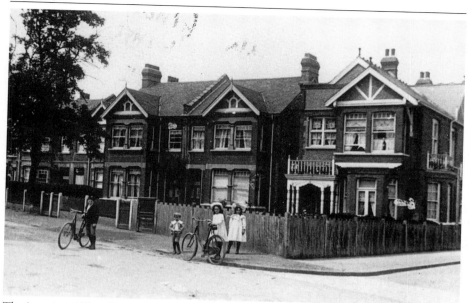

The junction of Lambert Road and Woodhouse Road before the coming of the trams in 1909. Like the other roads nearby, Lambert Road was laid out when the Woodhouse estate was broken up in the mid-1880s.

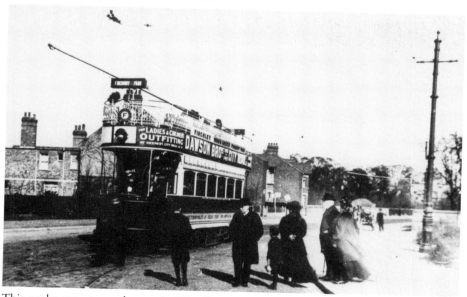

This early open-topped tram in Woodhouse Road, *c.* 1920, advertises Dawson Bros, ladies' and children's outfitters in the City because so many local residents worked there. Today workers come into the numerous offices in Finchley and Whetstone, rather than travelling away.

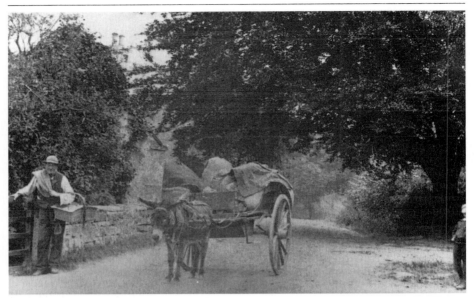

Nether Street, *c.* 1895. The man possibly had a local smallholding and used his donkey to pull the cart round the locality selling greengrocery. Nether Street got its name because it was on the far, or 'nether', side of Finchley Common. It continued up to Whetstone via Church Path.

County Alderman Fuller, chairman of Middlesex Education Committee, planting the 'Hitler' tree in 1937. The teams which visited the Olympic Games in Berlin in 1936 were presented with trees by Adolf Hitler. One of these was planted in the grounds of Woodhouse School to commemorate the coronation of King George VI.

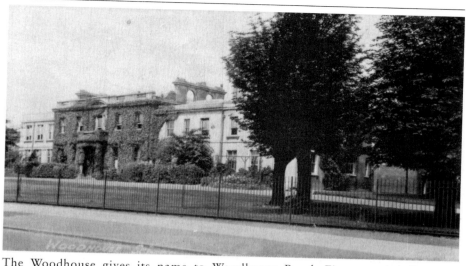

The Woodhouse gives its name to Woodhouse Road. First mentioned as the Woodhouses in the seventeenth century, the house seems to have a Georgian shape. It was modernized about 1888, and used as a school after December 1922. The railings were cut down during the Second World War.

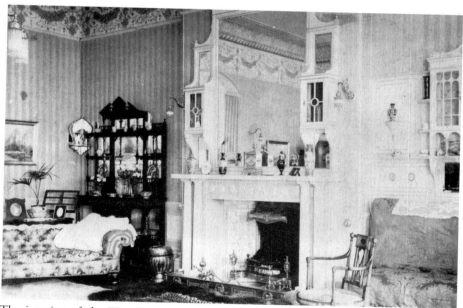

The interior of the Woodhouse, c. 1910. At this time the house was rented by the Busvine family, who used the drawing-room for dances on Thursday evenings. The music was provided by a player piano. The carpet was rolled up. The shallow well where the carpet formerly lay can still be seen in Woodhouse College, now covered with parquet flooring.

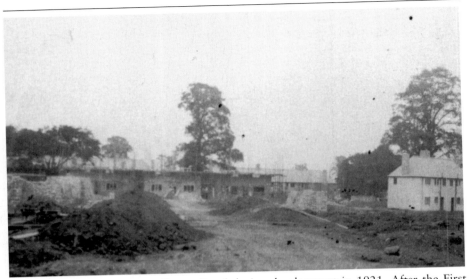

The Ingleway estate in Woodhouse Road during development in 1921. After the First World War there was a Parliamentary Order requiring local authorities to build good affordable houses for rent. The new houses, like those pictured, were then called council houses.

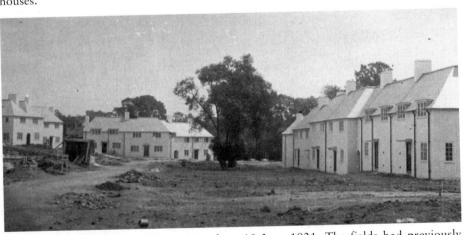

The Ingleway estate, now almost complete, 10 June 1921. The fields had previously been part of the grounds of the Woodhouse estate.

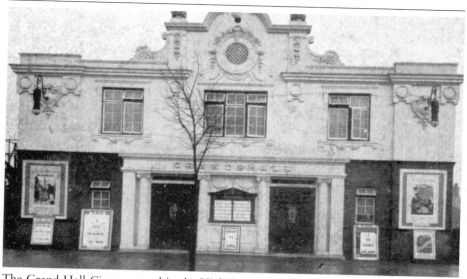

The Grand Hall Cinema stood in the High Road, North Finchley, *c.* 1920, immediately north of Market Parade. It was operated by National Electric Theatres. The chief projectionist was Mr Hudgell, who died in 1971. He had learned his trade at the Rink Cinema (see p. 130). His wife ran the Cosy Corner Café next door. The entrance to the cinema was down a side alley next to Geary's timber yard. The cinema was put out of business when the Gaumont, which stood opposite the Grand Hall, was opened in 1937.

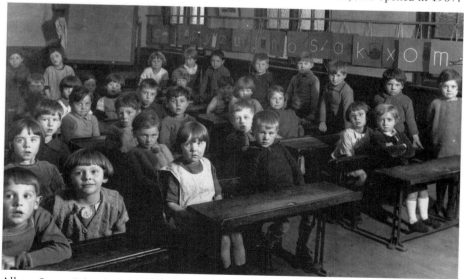

Albert Street School, *c.* 1928. These are 6-year-old children who are just beginning to learn the alphabet. R.J. Newton is in the second row in the centre desk. This school was built in 1884 and enlarged to take 930 pupils in 1898. It is now used by Northside Primary School. All the desks have ink-wells.

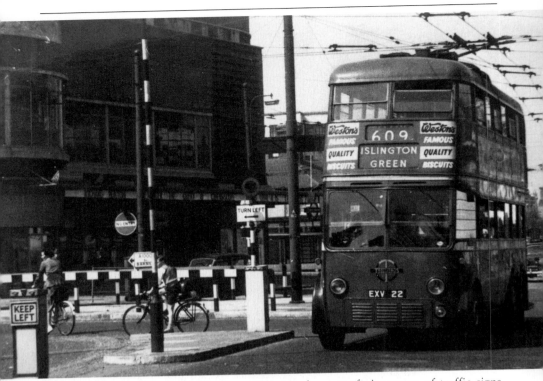

A 609 trolleybus passes the Gaumont Cinema plus a confusing array of traffic signs, c. 1950. The 609 usually ran to Moorgate, a reminder of the importance of the City of London as a major employer. The last trolleybuses ran in the winter of 1961/2.

# Miscellaneous

Sweet's Gun site in 1941. The former Sweet's Nursery land was requisitioned by the Army in 1939 and occupied by a battery of heavy anti-aircraft guns. These weapons fired a shell of a diameter of 4½ in, weighing about 50 lb, to a height of 8 miles. The intention, if not to hit the enemy, was at least to force him to fly too high for accurate bombing. After the war the land was retained by the War Office until 1969 when it was sold to Friern Barnet Council who used it to build houses and Queenswell Primary School.

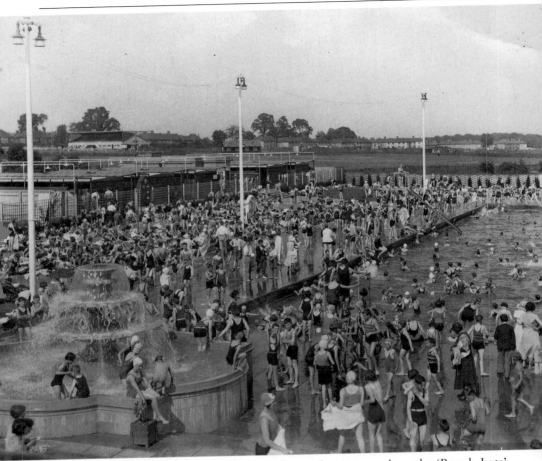

Finchley open-air swimming pool, 1933. The pool was opened on the 'Rough Lots' (former gravel pits) in 1932. It rapidly became immensely popular, on occasion the queues for admission running right down to the High Road and along the pavement.

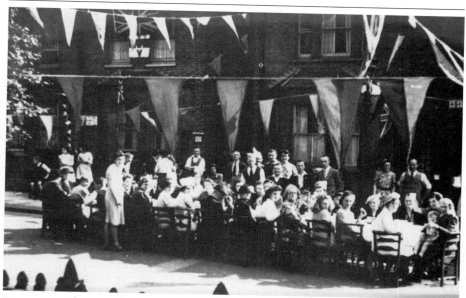

Victory in Europe (VE) Day was celebrated on 8 May 1945 by street parties. In particular folk made a point of switching on all their lights in order to celebrate the ending of black out. Flags that had probably been in store since the coronation of 1937 came out of hiding to add to the gaiety of the day.

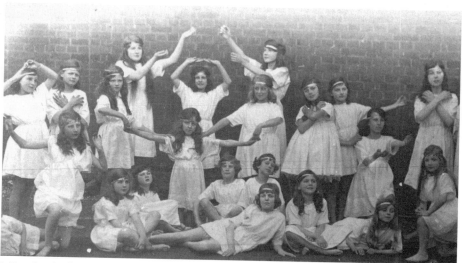

Miss Gayford's dancing class was held at All Saints' church hall during the 1920s. The influence both of Isadora Duncan and Dalcroze eurhythmics is obvious. The wide variety of individual expression encouraged by the teacher is exemplified by little Miss Una Pyke in the front row, right hand side.

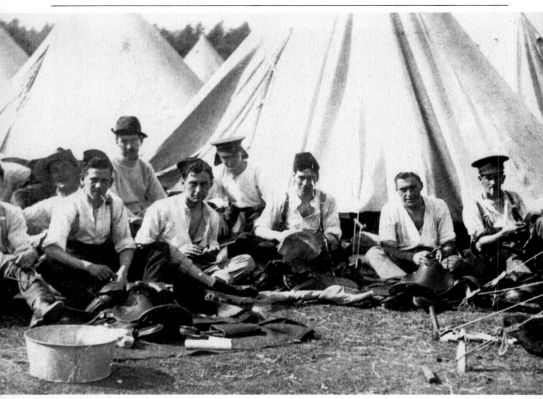

Members of the Middlesex Imperial Yeomanry enjoying the traditional military activity of spud bashing on Salisbury Plain in 1911. There is a long tradition of service in the Territorial Army in the district. Such service goes back to the days of the medieval trained bands and the practising of archery at the Butts in Friern Barnet Lane in the fifteenth century.

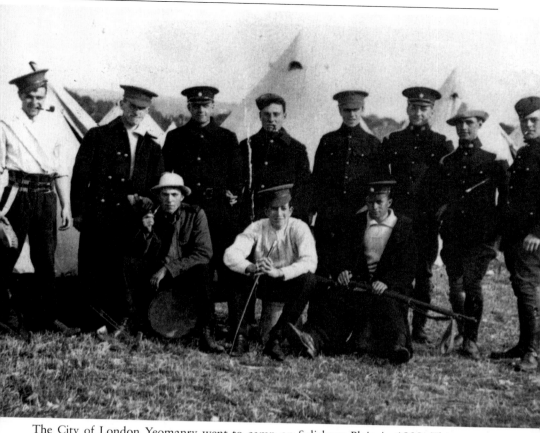

The City of London Yeomanry went to camp on Salisbury Plain in 1908. This was a regiment of part-time soldiers, who included E. Knight (on the left of the drum). Most of the recruits lived locally. Yeomanry regiments were more like cavalry than infantry.

One of the Busvine family proudly displays his Model T Ford, *c.* 1912. The family lived in the Woodhouse in the early part of this century.

The Gilmour family sitting in the garden of the Griffin Inn, *c.* 1880. As well as being a shopkeeper, Robert Gilmour was a church warden at St James' church in Friern Barnet Lane, where the family is buried. He was born in Scotland and came to Whetstone to seek his fortune about 1835. The dark skirts covering hooped petticoats and the cravats of the men suggest that they had all dressed up to have their photo taken. Snapshots had not yet been thought of!

# WHETSTONE, MIDDLESEX

## A CATALOGUE OF
## THE GROWING

# CROPS OF GRASS

## On 115 Acres,

### With the Afterfeed to the 29th of September next;
##### ALSO,

# A RICK OF MEADOW HAY,

## WELL GOT,
## Containing about 50 Loads;

## WHICH WILL BE SOLD BY AUCTION,
#### BY

# MR. DUCKWORTH,

### At the Farm, opposite the Bull Inn, Whetstone,

## On MONDAY, the 15th of JUNE, 1863, at 4 o'Clock,

#### (Immediately after the Furniture Sale,)

#### THE PROPERTY OF THE LATE MR. JOHN RAMSEY.

| LOT | | A. | R. | P. |
|---|---|---|---|---|
| 1 | The Growing Crop of Grass on 2 Fields near Pricklers Hill, with the After-feed to 29th September next, containing ... ..... ... .... ...... | 11 | 1 | 17 |
| 2 | The ditto on a Field at the corner of East-Barnet Railway Road, with the Afterfeed to 29th September next, . . ..... ...... ............... | 15 | 2 | 10 |
| 3 | The ditto on Water Meadow, North side of the Station, with the Afterfeed to 29th September next, ............ ... ......... ............. | 15 | 1 | 25 |
| 4 | The ditto on 2 Fields West side of Railway, with the Afterfeed to 29th September next, containing ........................ ........... | 14 | 1 | 17 |

## ON THE FOLLY FARM.

| | | A. | R. | P. |
|---|---|---|---|---|
| 5 | The Growing Crop of Grass on Field adjoining Lot 4, with the Afterfeed to 29th September next, containing ............ ..................... | 11 | 0 | 34 |
| 6 | The ditto on 3 Fields between Lot 5 and Hadley Common, with the After-feed to 29th September next, ......... ... ... ........... | 13 | 3 | 30 |
| 7 | The ditto on a Field East side of Railway, with the Afterfeed to 29th Sept. | 18 | 3 | 23 |
| 8 | The ditto on 2 Fields adjoining, and on Paddock, with the Afterfeed to do. | 14 | 1 | 10 |
| 9 | A Stack of excellent Meadow Hay, well got, standing by the Farm Yard, side of Hadley Common, containing about ...................... | 50 Loads. | | |

#### Conditions as usual, which will be stated at the Time of Sale.

☞ May be Viewed at any time prior to the Sale. CATALOGUES to be had at the Place of Sale; at the usual Inns; at Cowing's Public Library and "Press" Office, Barnet; and of MR. DUCKWORTH, Auctioneer and Estate Agent,

A reminder of the essentially rural nature of the district a hundred years ago. The growing crop was sold so that the purchaser could cut grass as and when it was needed.

# Index